THE INHABITED PRAIRIE

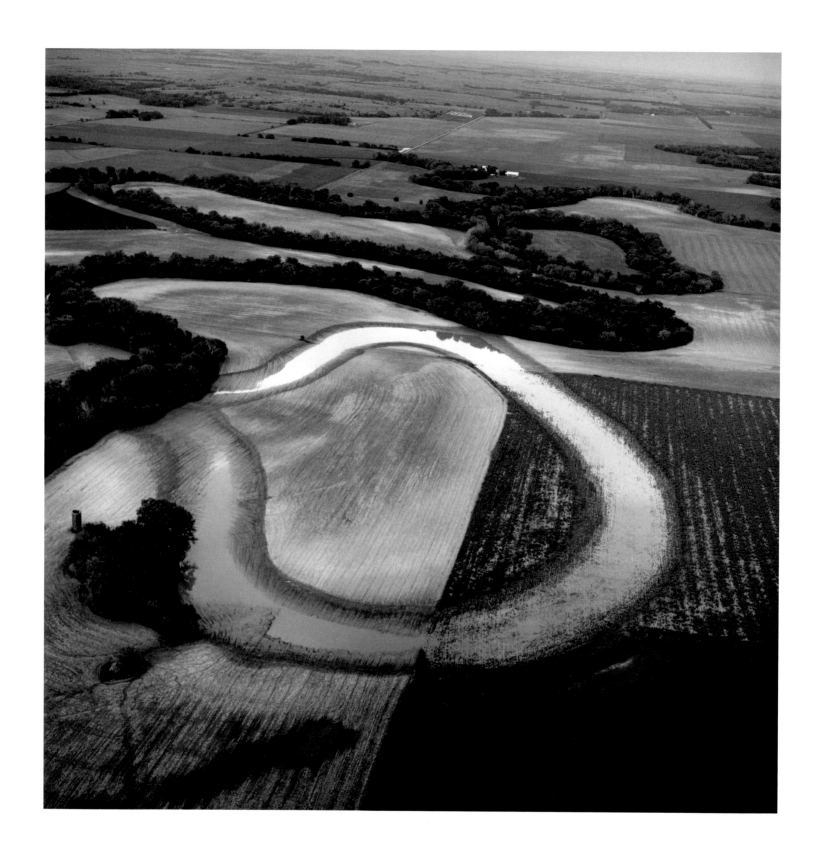

1. Solomon River oxbow, August 2, 1990.

THE INHABITED PRAIRIE

Terry Evans

Essay by Donald Worster

UNIVERSITY PRESS OF KANSAS

© 1998 by the University Press of Kansas.
Individual photographs © 1998 by Terry Evans.
"A Tapestry of Change: Nature and Culture on the Prairie"
© 1998 by Donald Worster.

Published by the University Press of Kansas
(Lawrence, Kansas 66049), which was organized by
the Kansas Board of Regents and is operated and funded
by Emporia State University, Fort Hays State University,
Kansas State University, Pittsburg State University, the
University of Kansas, and Wichita State University

Library of Congress Cataloging-in-Publication Data

Evans, Terry.
 The inhabited prairie / Terry Evans ; essay by Donald Worster.
 p. cm.
 ISBN 0-7006-0908-3 (cloth : alk. paper)
 1. Prairies—Kansas—Pictorial works. 2. Prairies—Kansas—
Aerial photographs. 3. Land use—Kansas—Pictorial works.
4. Land use—Kansas—Aerial photographs. 5. Kansas—Pictorial
works. 6. Kansas—Aerial photographs. I. Title.
F682.E83 1998
917.81'0022'2—dc21 98-13404
 CIP

British Library Cataloguing in Publication Data is available.

Printed in the United States by Meridian Printing
Designed by Ed King, Hillside Studio, Inc.

10 9 8 7 6 5 4 3 2 1

The paper used in this publication meets the minimum
requirements of the American National Standard for
Permanence of Paper for Printed Library Materials
Z39.48-1984.

To the memory of
Grace and Dean Evans

CONTENTS

PREFACE

There never was a people who tried so hard—and left so little behind as
we do. There never was a people who traveled so light—and carried so much.

Wright Morris, *The Inhabitants*

AFTER SPENDING EIGHT YEARS photographically exploring the fragmentary but still extant undisturbed prairie in Kansas, I came to a stopping point. It wasn't that I was bored with its intricate life, its sensuous colors and textures of grass, wind, and sky. It was just that I had photographed it to the limits of my vision. It was only the pristine prairie ecosystem that interested me then.

Four years later, a photograph by Peter Goin brought me to the rest of the prairie. The picture was taken on an abandoned Pacific island atomic bomb test site. It was of a large concrete mound, covering nuclear trash, with a red circle painted around the top and a red cylinder sticking out of the middle. Peter said that to U.S. soldiers flying over this site, the mound looked like a woman's breast. I remembered an aerial view of mine of the unploughed Konza Prairie, near Manhattan, Kansas, in which the prairie hills looked like a woman's breast. Suddenly, I realized that the inhabited prairie was part of the body of prairie and that I could not understand prairie if I didn't look at the whole of it. The disturbed, cultivated, militarized, industrialized prairie had been abused as surely as that small atoll in the Pacific Ocean. I began to photograph the rest of the prairie.

In photographing the untouched native prairie, I'd often worked at waist-high distance, fascinated by the endless complexity of forbs and grasses on the ground. I'd searched for pattern close-up. But looking at the ground of a wheat field is different. There is only wheat and ground. If I wanted to see the simple patterns of agriculture and other human land use, I would have to go higher.

I was a detective on a search for evidence of the abuse of prairie. I expected to see the degradation of the prairie by military use, large-scale agriculture, and mining industries.

I climbed into a Cessna 172 and began to explore from a distance of seven hundred to one thousand feet above the ground. I drew a circle on my map of Kansas that showed a twenty-five mile radius around my home, Salina. This was a comfortable range of exploration for the hours of long shadows after sunrise and before sunset. The subtle prairie landforms require slanting sunlight to define their shapes. We flew high enough to see the grid but low enough to see a deer wandering across a bombing target, totally at home on the weapons range.

Over the next five years, I would work with two pilots, both military. Duane Gulker had become a corporate pilot after retiring from the U.S. Air Force, and he flew with me for three years. Then came Major Jonathan Baxt, who was the manager of the National Guard's Smoky Hill Weapons Range, and my neighbor across the street. The pilots became my dance partners. We learned how to dance together so that by a movement of my hand, Jon would know how to bank the plane. When I had to change film, Duane would notice and would circle the location until I was ready to proceed.

Jon Baxt partially revised my original assumptions about the Smoky Hill Weapons Range by showing me thirty-four thousand acres well managed for grassland, pasture, and wildlife. Other stories revealed by the facts of the landscape also changed my preconceptions. I found that I was no longer looking for abuse of the

prairie. Instead, I was simply trying to read its stories from the facts of the landscape. I saw a small carefully tended cemetery in the middle of a wheat field, and carefully nurtured farms, along with land mined on top for wheat and underneath for oil. The prairie contains in her breast many stories of use and misuse, care and neglect. I'm learning how to recognize them from the air and explore them further on the ground.

I met the Johnson brothers, both in their eighties, when I stopped one day at their farm to ask Kenneth if he could tell me about his land. I'd heard it contained an Indian village site from the Smoky Valley people circa 1500 AD. Kenneth said, "Well, sure, you can ask me questions, but I don't know much. We've only lived here fifty years." They found points and scrapers and other Native American tools regularly when they plowed their wheat fields. They kept the best ones, real beauties, in an old envelope on the kitchen table.

I asked Kenneth and Leibert if they knew anything about the slabs of rock, which looked like walls, in a field near the Smoky Hill Weapons Range eight miles west of their farm. "Well, yes, that's an old German prisoner-of-war camp from World War II. Our homestead was near there, but the U.S. Army came in 1942 and forced us to leave so they could build Camp Phillips, and we came here."

Layers of use, layers of loss and recovery and loss again, vestiges. These photographs are neither a critique of land use nor a statement about the irony of its beauty. The photographs are not about abstract visual design; they are about specific places. They show marks that contain contradictions and mysteries that raise questions about how we live on the prairie. All of these places are beautiful to me, perhaps because all land, like the human body, is beautiful.

A TAPESTRY OF CHANGE

Nature and Culture on the Prairie

by Donald Worster

THE PAST IS A LIVING TAPESTRY that begins under our very feet and unrolls over the hills and valleys, the farms and villages behind us. Some of its threads can be picked out as distinctly cultural, but most are purposeless skeins of water and air, green pigments of chlorophyll, ribbons of DNA, flashes of sunlight. We may call some of that fabric "history" or "economics," the rest "evolution" or "geology," but it is all one past.

If you want to grasp the rich complexity of that tapestry, you could do worse than spend some time on the North American prairie. Here, the intricate weave is out in the open for anyone to scrutinize. The great bowl of sky brews the continent's most unstable patterns of weather, an instability that drives both human and nonhuman life in unique directions. The limited rainfall is matched by great gusty winds, causing the high rates of evaporation and low soil moisture that explain the dominance of grasses over trees. Underfoot, the dark brown earth is the product of ten thousand years of organic chemistry, though before that Holocene soil existed, there were other soils, and before them were vast inland seas, the primordial source of life, now solidified into chalky swells breaking the surface. Natural selection has thrown out such innovations as the pronghorn, the prairie dog, the big bluestem grass, and the little blue grama. And here too have come, though only in the last few moments, a succession of human settlers. Like all forms of life, they have been tested for their adaptive skills, though none has been tested for all that long.

A few centuries ago, the North American prairie was still beyond the ken of western civilization, except for the quixotic band led northward by Francisco Vasquez de Coronado in the 1540s. Tens of millions of bison were the largest assembly of legs and brains to be seen. Several hundred thousand Indians, the descendants of people who had been gathering and hunting here for at least ten millennia, defined what it meant to be human. Today, the prairie has not only been "discovered," it has been radically changed—changed perhaps more than any other biome in what we now call the United States. Americans have invaded with ferocious speed and in a geological instant have rewoven the ancient grassland into corn-land, wheat-land, pig-land, cattle-land. Our innovations, like nature's, continue to proliferate but at a far more rapid rate: cattle feedlots, natural gas pumping stations, four-lane highways, truck stops, gated communities, irrigation systems.

Here on the prairie, or what once was prairie, we can find revealing lessons in what humans have done to the earth and what that doing has done to us—lessons of success or failure in cultural as well as in biological terms. Many other such tapestries of change offer themselves for study: places like the prairie that are no longer wild or natural or pristine but where the age-old conversation between humans and the natural world ceaselessly goes on. It may be, however, that this one stretching across the middle of our continent is the most instructive we've got.

Artists, like historians or biologists, have had difficulty in rendering the full complexity of the prairie, past and present, human and nonhuman. It is hard to know where to stand to get a good picture, one that includes everything from the sight of clouds drifting overhead to the taste of dust, from the bones of plesiosaurs to the tin cans of landfills. It is even harder to know how to fit the prairie into conventional aesthetics. Outdoor pictures are supposed to be scenes of romantic or picturesque beauty, and the prairies have seldom met that ideal for most people. Tutored by the likes of Ansel Adams, our landscape photographers have been drawn more to forests and mountains, especially forests and

mountains in a state of sublime wilderness, and only a few artists have spent much time on the prairie or tried to figure out how to get its tangled, intricate weave into a revealing frame.

During the nineteenth century a growing number of Americans discovered the beauty and value of wild nature, qualities that brought them excitedly into landscapes that had been for earlier generations dark, dangerous, forbidding places that should be avoided or cleared away. Over the many centuries before encountering North America, Europeans had become well practiced in clearing land: they had removed all the trees they could, turning land into row crops or grassy pastures. But under the influence of the romantic movement, western civilization began to alter profoundly its prejudices against the forested environment. A shift in aesthetic thinking occurred. Mountain hiking became a popular sport. Forests began to inspire reverence instead of repugnance, and their conservation became one of the great triumphs of the late nineteenth century. Wilderness, nowhere more so than in North America, became a standard by which to judge civilization, rather than the other way around.

Those have been profound changes, and I hope they last for a long time, spreading to save the surviving rain forests of Brazil and Borneo. We humans need, for our own ethical development as much as for the sake of biological diversity, to leave some part of the world's evolutionary fabric free to do its own weaving, independent of our interventions or control. However, like any important change this one on behalf of wilderness came at a cost. The biggest cost was not economic—the loss of potential wealth in setting aside a few small fragments of nature. Nor was it a social cost—a misanthropic turn away from human welfare. Quite the contrary, it can be argued that we are more rich and humane precisely because of that movement toward embracing wilderness. The biggest cost was that many significant biomes were not included in the new wilderness ideal. Any place that lacked forests or mountains tended to become unimportant, unvalued, uninteresting. People went looking for the big trees, and they passed over the millions of treeless acres that did not attract their affections.

As luck would have it, the prairies did not really enter American consciousness (as opposed to Native American consciousness) until after the modern passion for wild, forested mountains had begun to stir. The first Americans to describe the western prairie, Meriwether Lewis and William Clark, came in the years 1804 to 1806, and all they saw of it was from the verges of the river. James

Fenimore Cooper's novel *The Prairie,* inspired by other scientific explorations, did not appear until 1827, and that was getting a little late to shift American enthusiasm from the vertical to the horizontal.

As rural settlement followed exploration, the popular mind began to encounter landscapes that were quite unlike anything that people of European ancestry had seen before or learned to appreciate: first, the oak openings of Ohio, where grasses began to contest successfully the reign of trees, then the tallgrass prairies of Illinois and Iowa, then finally the Great Plains. Americans began to realize that those grasslands constituted the vast heart of the continent, so that whatever America would become would, to a significant extent, be determined by their use and settlement. Yet the prairie remained strange to people, and even repellent; its level to rolling landforms and its low vegetation were hard to get used to or appraise or fit into an idealized nature.

European tourists were often the most quick to judge the prairie harshly. Curious to see it for themselves, they were often disappointed by what they saw and had no desire to linger. Charles Dickens, for example, consented to be led on a day trip from his Saint Louis hotel to examine the Looking Glass Prairie of Illinois, arriving just as the sun was setting. He dismissed the scene before him as a "great blank."

> Great as the picture was, its very flatness and extent,
> which left nothing to the imagination, tamed it down and
> cramped its interest. I felt little of that sense of freedom
> which a Scottish heath inspires, or even our English downs
> awaken. It was lonely and wild, but oppressive in its
> barren monotony. . . . It is not a scene to be forgotten, but
> it is scarcely one, I think . . . to remember with much pleasure,
> or to covet the looking-on again, in after life.*

Others, nationals and foreigners alike, complained about prairie monotony, prairie flatness, prairie vacancy. Or they felt threatened by its bigness, its impersonal scale. Even ecstatic nature lovers often objected that this landform offered insufficient shelter or inspiration.

More practical-minded travelers feared that the prairies were infertile and would remain a perpetual wasteland, blocking settlement. The fact that this country did not grow many trees was

* Charles Dickens, *American Notes for General Circulation* (1842), in *The Works of Charles Dickens*, Vol. XIV (New York: Bigelow, Brown and Co., n.d.), 237.

taken as clear evidence that its soils were bad. The best that could be offered in its defense was the counterargument that the prairie would have grown trees—perhaps grown them all the way to the Rockies—if the Indians had not persisted in burning the ground regularly. Such theorizing was wrong on both counts; the prairie was neither infertile nor deforested only by Indian firings, but it was a while before the hardheaded realists realized their error.

We should not overstate the negative press the prairie got. A scattering of women and men liked what they saw and wanted to live here, out of the gloom of the forest. Some even wanted to preserve the grasslands before they were destroyed by land hunger. The Philadelphia artist George Catlin traveled up the Missouri River by steamboat and down the same river by canoe in the summer of 1832. Stretching out one afternoon on a rise above Fort Pierre, he dreamed that the whole prairie, "from the province of Mexico to Lake Winnipeg on the North," a land which "is, and ever must be, useless to cultivating man," might be set aside as the perpetual home of the bison and its Indian hunters. "What a beautiful and thrilling specimen for America to preserve," he wrote, "and hold up to the view of her refined citizens and the world, in future ages! A nation's Park, containing man and beast, in all the wild and freshness of their nature's beauty!"* Had the nation acted on that dream, a single wilderness preserve greater than all of Alaska would have been set up straight across the path of manifest destiny. But the nation was not ready for that idea in the 1830s, and in fact it would never be ready for it. No national park to preserve the grasslands would be established by the United States until 1996, though exactly forty years after Catlin's dream the Yellowstone country, a more appealing wilderness of superb mountains and forests and a land more out of the way of the westward movement, would become the world's first national park.

The fate of the prairie tapestry was otherwise. Rather than being preserved intact as an ancient, complex, many-threaded, evolution-tested mosaic, the prairie was largely obliterated. The method used was to print the land over from end to end with a simple checkerboard design, to cut it up into several million little squares. We call them "quarter sections." They were the product of the most sweeping, fundamental innovation the human mind ever tried to impose on this landscape, a system for surveying the land on a grand scale.

Officially, we called this innovation the U.S. Rectangular Land Survey. Unofficially, it was simply "the grid." The grid organized the landscape into exactly alike townships, each six-by-six miles in size, then divided them into thirty-six sections of one square mile each, then divided each of those sections into quarter sections, each measuring 160 acres. Today, we are so familiar with the pattern, if we live in the countryside, that it may seem as natural as a meadowlark singing from a fence post. Yet the origins are as alien to the prairie as they could be. Some scholars trace the grid back to the ancient Roman field system of the centuria, which marked off fields in lots of 100 geometrically correct squares, though the grid also appeared in Egypt, China, and Japan, indeed, wherever people sought a symbol of rational secular order. Whatever its Old World origins, this much is indisputable: Thomas Jefferson, an admirer of classical civilization and a proponent of eighteenth-century rationalism, first proposed bringing the grid design to North America to serve as the basis of a land system. Congress followed his suggestion in 1785.

The foremost historian of the grid, Hildegard Johnson, explains that its appeal lay in an "easy transfer of land and thus land speculation and sales." She goes on to say that it expressed a cultural view of land "as a standardized commodity," adding that "the desire for assured ownership of separate property parcels required simple and accurate descriptions of landholdings, and the Ordinance of 1785 was a plan in support of such possessive individualism."†

In other words, the grid was not a design that had developed slowly in place, as tradition responded to environment over time, nor was it the finely balanced outcome of many local decisions interacting with the shifting flow of water, the patchiness of soil, the movement of organisms. Instead, it was arbitrary, abstract, and imperial. It suited a new market orientation in the perception and use of land. Had a similar rigidity been slapped down on the personal freedoms of Americans through law or regulation, it would have been fiercely denounced as authoritarian in the extreme. But instead the grid was welcomed as the perfect means to settle the country rapidly and to make every man a king on his own estate.

The grid had its beginning point where the Ohio River flows out of Pennsylvania, and from there it unrolled westward over more than one billion acres. That is, on paper it did. On the

* George Catlin, *Letters and Notes on the Manners, Customs and Conditions of the North American Indians* (1841; New York: Dover, 1973), 261–62.

† Hildegard Binder Johnson, *Order upon the Land: The U.S. Rectangular Land Survey and the Upper Mississippi Country* (New York: Oxford University Press, 1976), 20, 36.

ground, the situation was somewhat more complicated. The Rocky Mountains and western deserts, rugged in terrain and arid in climate, resisted the uniform scheme as an actual settlement plan; much of that country never was gridded nor fell into the hands of homesteaders. The open prairie, on the other hand, was everywhere vulnerable to its rule. The plow quickly followed the surveyor's lines. Hundreds of millions of straight furrows were cut across the grassland weave. A sound of ripping filled the air. A rich odor of exposed earth rose from the furrows. Long-accumulating fertility fed a new agriculture. The land yielded to wind and water, Iowa losing half its topsoil in its first century and a half of settlement. And, often oblivious to that loss, the new landowners each became a feeder of masses.

Ironically, the gridding of the grasslands allowed the counter-ideal of wilderness to flourish elsewhere. Much of New England began reverting to forests in the second half of the nineteenth century. Lands that had been laboriously cleared for sheep pastures or hillside farms reverted to second-growth woodland, the heavily framed houses and rail fences decaying back into the soil. Even in densely settled Massachusetts or Connecticut, land began going out of production as prairie farms took over the provisioning of cities with bread and meat. Today in those older states, the wilderness has made a second coming, and moose, deer, bear, and beaver thrive again as they did before Puritan times. Farther west, meanwhile, beyond the prairies, the wilderness has survived the coming of industrial civilization more intact than it might otherwise have done. To be sure, the Far West has seen intensive irrigation development, turning the Central Valley of California into a look-alike of the midwestern agricultural regime, and massive urbanization. But the old prairies in the watershed of the Mississippi, the Missouri, and the Platte Rivers provided such abundant returns with such easy access to market that many western landscapes were spared what might otherwise have been their fate.

In effect, a deep contradiction had opened up in American attitudes regarding land. On the one hand, a romantic love of wilderness, hungry for natural beauty and natural freedom and insisting on the intrinsic worth and value of the nonhuman, pushed us toward a change in consciousness; on the other hand, a utilitarian devotion to intensively managing and using land, which justified itself in the name of wealth and progress, resisted change. We have not yet resolved this contradiction, either in our private feelings or in our public policies, and it is unlikely we ever will.

A few years ago, I returned to live on these Kansas prairies after a quarter-century of living elsewhere, and what I found on my return was a movement stirring to rediscover the prairie we have lost, to preserve and protect what is left, to reinhabit the grasslands. I discovered a new generation of prairie artists, photographers like Terry Evans, who are seeking to alter the way we perceive both the natural and the cultural in this underappreciated landscape. Their mission seems to be to find some middle ground between our far-apart ideals of wilderness and grid; to promote a new wave of resettlement that is informed by science, ethics, and aesthetics as well as economics; to insist that nature should include not only the pristine places far removed from economic activity but also our daily surroundings where we have to make a living. Above all, and most difficult to achieve, the new movement aims to persuade a nation that the prairie ought to be regarded as more than a commodity to be subdivided and sold.

Anticipating such a movement was the wildlife scientist Aldo Leopold, a man who made his own move back to the midcontinent some seven decades ago. In 1924, Leopold left a Forest Service career in New Mexico to relocate near his first home: born in Iowa, he returned to Wisconsin. He did so not because he missed the grid or industrial agriculture. Leopold was never a farmer and was never a fan of what modern farming had done to the grasslands. In his essay "Illinois Bus Ride," written on a trip across that state, he expressed what was wrong with much of our rural land use. The agriculturist is often unaware of how vulnerable he is, Leopold writes, because he has no sense of evolution, no appreciation of the prairie tapestry that once covered his land and still furnishes its productivity. The fellow passengers on the bus were little better; for them, Leopold wrote, "Illinois has no genesis, no history, no shoals or deeps, no tides of life and death. To them Illinois is only the sea on which they sail to ports unknown."*

Leopold came back to search for a deeper, better informed human-land relationship. It must begin, he believed, with the integration of biology and history. If we understand the prairie tapestry only in terms of present-day science, we will miss the long unfolding of possibilities that has gone on before us in this place, setting the terms for our habitation. But if we understand the world around us only in human terms, or only in Euro-American

* Aldo Leopold, *A Sand County Almanac* (New York: Oxford University Press, 1949), 119.

terms, we will fail to understand the ecological whole of which we are inextricably a part.

Leopold came to that more inclusive point of view by carefully looking around him out of doors, asking what was there, what had been there, how the two were related. I know that he read a few history books, though most historians in his day were still not prepared to acknowledge the land as a vital, active agency in the human story. Even now historians (and I say this as one of them) are only a little better prepared for putting the human past into its full ecological context, for conceiving of a past that includes not only politics, social relations, and human ideologies but also sand-hill cranes and soil nematodes, sloughs and moraines, winter blizzards and summer droughts. We historians still have to get outdoors more often than we do and look at *all* that has been going on, though increasingly we are trying.

Let me relate a few things about prairie history that I have learned from walking along the ground, from peering through the windows of an automobile, from getting up in an airplane and looking down on a land that I thought I knew, and from studying the insights of natural scientists like Wes Jackson and the photographs of artists like Terry Evans.

One of my most startling discoveries is the extent to which the nineteenth-century grid, imposed with such an assured sense of permanence, has begun to alter or even fall apart. These days it is no longer quite the major defining force in the prairie landscape it once was. I do not say it has disappeared, for it is still there, as anyone knows who gets up off the ground far enough to see. The grid is particularly impressive from a height of about thirty thousand feet, where the earth and human life alike become highly abstract. But come down closer, down to seven or eight hundred feet above the surface, and the grid begins to lose its sharp lines, its clarity, and its power. Indeed, it is difficult to find these days a portion of the grid that has remained fully intact, except perhaps in the less settled plains of eastern Colorado.

Much of that erasure has been, and is, the work of humankind. The landscape that Americans once tried to create without much thought or experience, they have been tearing down and taking apart, again without much thought or intention. They started in the last century with the railroads, which almost never conformed to the checkerboard section lines. The railroads went their way across the land, disregarding the great rectangular design, indeed paying more attention to the actual terrain than to the global abstractions of the federal land survey. The first railroad that came

through this state, the Kansas Pacific (it arrived soon after the Civil War), did not make any attempt to follow the land surveyors' lines. It began at the mouth of the Kansas River where that river joins the Missouri (the site of present-day Kansas City) and proceeded upstream along the Kansas, then up the Smoky Hill River, finally striking out across the high plains toward the bustling new city of Denver, built at the confluence of the South Platte River and Cherry Creek. Rivers were pathfinders for the steel rails. The other major railroad of the state, the Atchison, Topeka, and Santa Fe, started construction about the same time and followed the well-rutted Santa Fe trail southwest. By 1900, the state had built almost ten thousand miles of railroad track, all converging at that same mouth of the Kansas River. The railroad corporations had laid out brick and wooden towns along their tracks, every thirty miles in the western counties, requiring only a day's wagon ride for a farmer with grain to sell. Farmers, whatever the boxy shape of their estates, had to reorient their lives to that potent nonconformity of transportation. So did the grain elevators, the feed stores, the implement salesmen, all of them forced to follow the rails that slashed across the prairie tapestry.

Soon other forms of travel diverged from the grid as well. The land surveys allowed no arteries of movement among the checkerboard squares, and when the farmers attempted to lay out dirt roads, they had to shave several feet off their section lines. In the early years of taking grain to market, they tediously followed the grid lines, as they still do today while traveling on the back roads: turn right, turn left, turn right again. It was a slow, inefficient way to move, and because the grid disregarded the lay of the land, the roads often put a severe strain on the draft animals pulling wagons up hills that weren't supposed to be there. When paved highways came along, however, during the 1920s and after, their builders did not make the same mistake; they imitated the example of the railroads, cutting across the landscape on paths that were the easiest for their construction crews to blaze and for automobiles and trucks to travel.

So transportation sought to liberate itself from the rigid, inefficient abstractness of the rectangular survey. So too did the seekers after the fossil fuels that were needed to power that transportation network. The grid was dreamed up long before anyone had thought of pumping oil out of the ground; it was not a landscape designed for modern energy flows. Finding and getting to the likely sites where petroleum or natural gas lay pooled underground encouraged more indifference to the checkerboard. The

drilling crews invaded the square plowed fields, put their wells down in the midst of wheat and sorghum, made haul roads and pipelines that went straight from the wells to a booster station or a refinery.

All of those nonconformities were simply following the logic of an industrial, capitalistic economy that was determined to drive the straightest, easiest line between natural resources and markets. The spatial demands of that economy proved to be far more complicated than early Americans ever anticipated, and the prairie tapestry began to show an asymmetrical web of lines no one ever dreamed of in Thomas Jefferson's Age of Reason.

We can speak of these developments as the evolution of a corporatized prairie. Massive economic organizations did not hesitate to make or remake the land and society to suit their own purposes, and they destroyed whatever was inconveniently in their way. I don't find their markings on the land, any more than the powers behind them, easy to admire or love. The sometimes fearful bigness and impersonality that the unsettled prairies presented was replaced by the alienating bigness and impersonality of the corporate economy, which has thrown its lines out to the most remote parts of the grasslands as it has all over the globe with the single-minded intention of making nature over into money. But those latest markings, though drawn by a giant and ruthless hand, undoubtedly weave a tapestry more interesting to the eye and mind than the simple, static plan of another century—an ever-changing network of power, with lines aggressively crossing, competing, and converging.

Distinguishable from those corporate markings on the land but likewise running counter to the grid are patterns drawn by modern soil conservation. Contour plowing and terracing, two important tillage techniques developed during the Dust Bowl thirties, reshaped the cultivated landscape into still another kind of complexity. Plowed furrows, many farmers began to see, must follow the shape of the land, not some abstract scheme sketched in a land office. Farmers had to unlearn old habits and master new ones to save their soil and water, and not everyone has found it easy to do that. Even now, prairie farmers, who have become technically proficient in running their machines along the contour levels, often find it difficult to work together across their individual property boundaries. Contouring changed the agricultural landscape, but it did so in limited, scattered ways, producing a haphazard series of "crazy" patches on a still predominately individualistic, private-property quilt.

Still another nonconformity has been the growing American military establishment, which like so many other innovations could not have been imagined by the original homesteaders, even in their most bloody wars to dispossess the native peoples. Not until World War II, a war fought in the air as much as on the ground, did this new agency of landscape making come to the prairies. In 1942 the federal government took over a large portion of the Smoky Hill uplands as a base for its long-distance bombers. Like other such sites, this one was deliberately located far inland for security against overseas enemies; and that quest for international security brought a radical new way of using the prairie, one that continued through the ensuing decades of the Cold War, becoming more and more sinister as it became more and more pointless. It has created shapes on the ground that have nothing to do with producing agricultural crops or corporate wealth: enormous bull's-eyes for targets, concrete bunkers, underground missile silos that local residents seldom see, never visit, know little about. Come upon in the grass, they are a chilling reminder that atomic bombs had been buried here, ready to erupt into the sunlight and scream violence all the way to Moscow or Beijing.

The official purpose of such bases was to protect American lives and interests from distant threats. Unexpectedly, however, installations like the Smoky Hill Air Force Base ended up protecting the prairie itself from encroaching economic uses. The base preempted ranches, highways, and factories from occupying large swathes of land. The wildlife that had survived the farmer's invasion now found a refuge amid the carcasses of wrecked planes and the shards of exploded ordnance.

All those are ways that the original grid has been challenged, altered, and disrupted for the needs, the hopes, and the fears of an evolving society. But that is not the only unraveling of the grid that recent history shows. Nature too has been at work since white settlement began, chewing on the section lines, flooding the squared-off fields, forcing humans to adapt to an unconscious power that has millions of persistent years behind it, a power that is not likely to be defeated completely, or held off for very long, even by the energies of modern technology.

Evidence of nature's resistance to man's incursions abounds everywhere on the Great Plains. Go out to western Kansas and locate the old Solomon River, which flows from the high plains tableland. Follow it eastward more than two hundred miles, watch it get impounded by several Corps of Engineers dams and survive, then observe it as it continues on to its confluence with the Smoky

Hill River. You will see how it insists on meandering along as it has done for millennia. How could people ever have expected to control that primeval force by private deeds or barbed wire fences? The Solomon still twists and winds, still creates oxbows, still seeks a route for itself in accordance with the laws of fluid dynamics. Now and then in high water years it breaks through its banks to reclaim an ancient riverbed.

Everywhere, in fact, the deep natural history of the prairies keeps breaking through the order and authority of human enterprise, continues to unfold in ways that defy the best-capitalized and best-technologized schemes. Wetlands may be drained, but for how long? Stop plowing and the grass returns, the trees find protected niches against the drying winds. Even where the farmer thinks he is in firm control, where he has plowed an expert contour to retain the moisture, a herd of deer may stroll out of the brush and graze on his winter wheat. Or loop across a bare field, leaving hoofprints alongside the tread of a tractor. Nature reclaims instantly whatever man abandons, and his abandonments are multitude. A tree grows out of a disused grain silo. Wind and rain collapse the roof of an old barn. Fences sag and fall. The land restores itself, not to some fixed primeval state but to a future that may or may not include us.

Indian settlements far older than the white man's have nearly disappeared from the prairie by the late twentieth century—settlements where men, women, and children once held what they assumed was permanent occupancy. Their villages, though they may have lasted for hundreds of years, have become almost invisible; it takes a keen, instructed eye to find their traces on the plowed ground. But then the same may be said for many white habitations that have come and gone over the past century or so. Their traces too have been quickly covered over. And where are their descendants today?

The historian of the prairie who thinks deeply about the place has to acknowledge that we have around us a landscape that is and has always been in constant flux, and not all of that flux amounts simply to a story of civilization replacing nature. On the contrary, the dynamics of change often go the other way, so that nature is never simply conquered and replaced once and for all but is always making a return.

Is it inconceivable that farming itself may someday disappear over large sections of the midcontinent, whether due to the economic logic of the market or to the blind processes of nature or to some unpredictable combination of the two, like a change in the climate brought on by burning fossil fuels? We may see millions of acres largely abandoned to nature, just as they have been in New England. We may even see the bison return, along with the indigenous grasses, as the beaver and bear have come back to Massachusetts, and they may begin to reoccupy a land they once dominated for more years than we have existed as a species.

Studying the prairie's history, I have been suggesting, is a more complicated and difficult task than we have imagined. It requires a deeper sense of time, deeper than the lives of pioneers, the passing of laws, the laying of rails, the pumping of oil. It needs a sense of time that is as deep as the soil, as broad as the sky. Lacking that deep understanding of place, we Americans, in our short term of occupancy, have made a number of foolish decisions about this place, created a string of failures, and at times snarled up the tapestry pretty badly. We have left an astonishingly large number of cultural fossils in the dust. To untangle those snarls and lessen the failures, to improve our chances for long-term survival, we need to become more aware that the prairie's past lies beyond any easy understanding. Much of it is mysterious, a "great blank" that conceals more than it reveals, and all of it will be different tomorrow from what it is today.

THE INHABITED PRAIRIE

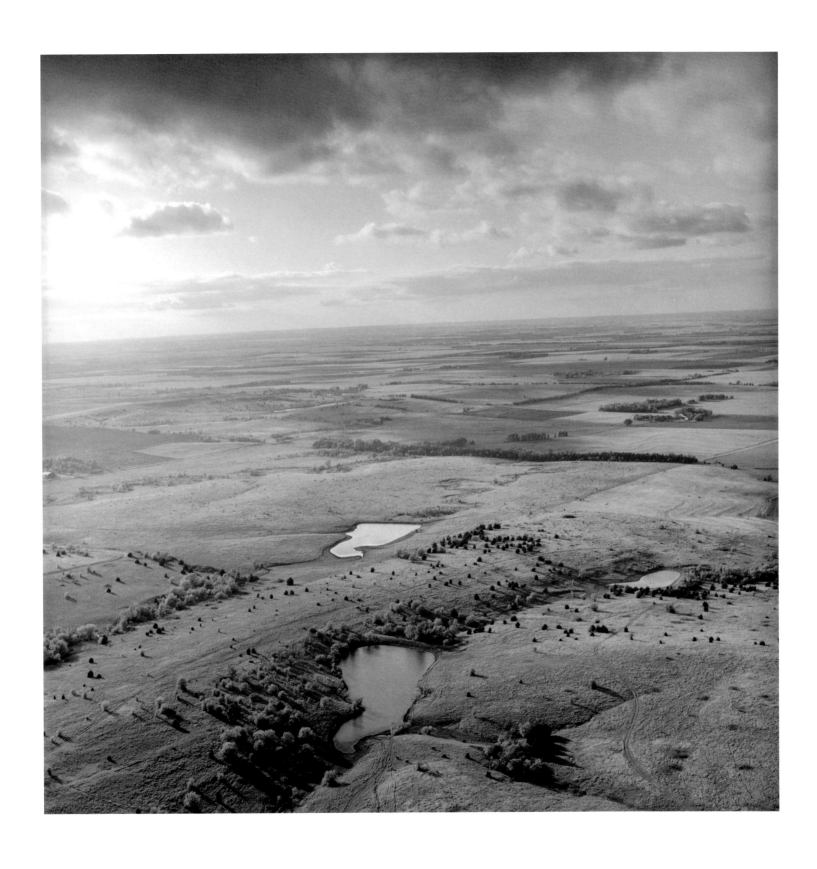

2. Ponds and sky, western Saline County, May 8, 1991.

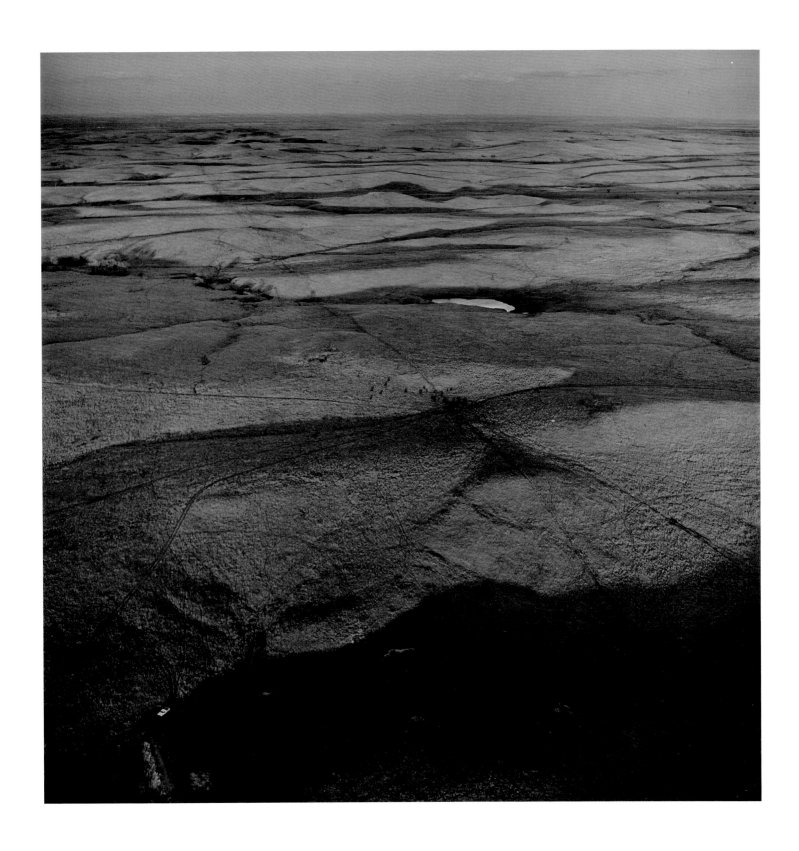

3. Pond and car west of Minneapolis, Ottawa County, April 27, 1990.

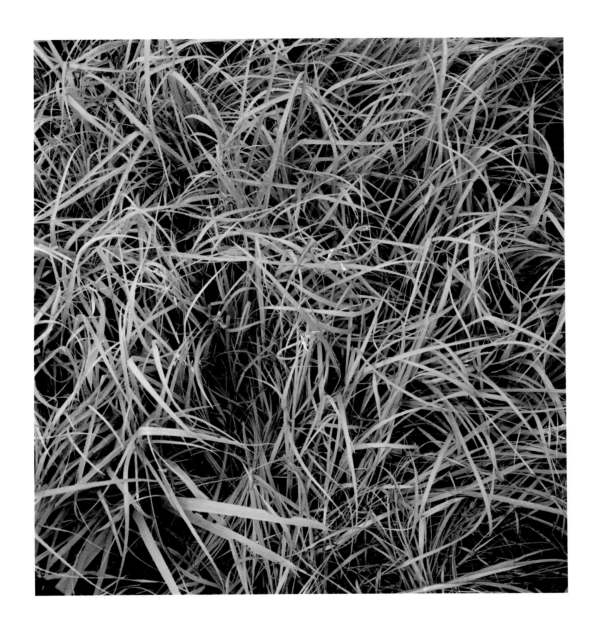

4. Prairie grasses, The Land Institute, Salina, August 3, 1990.

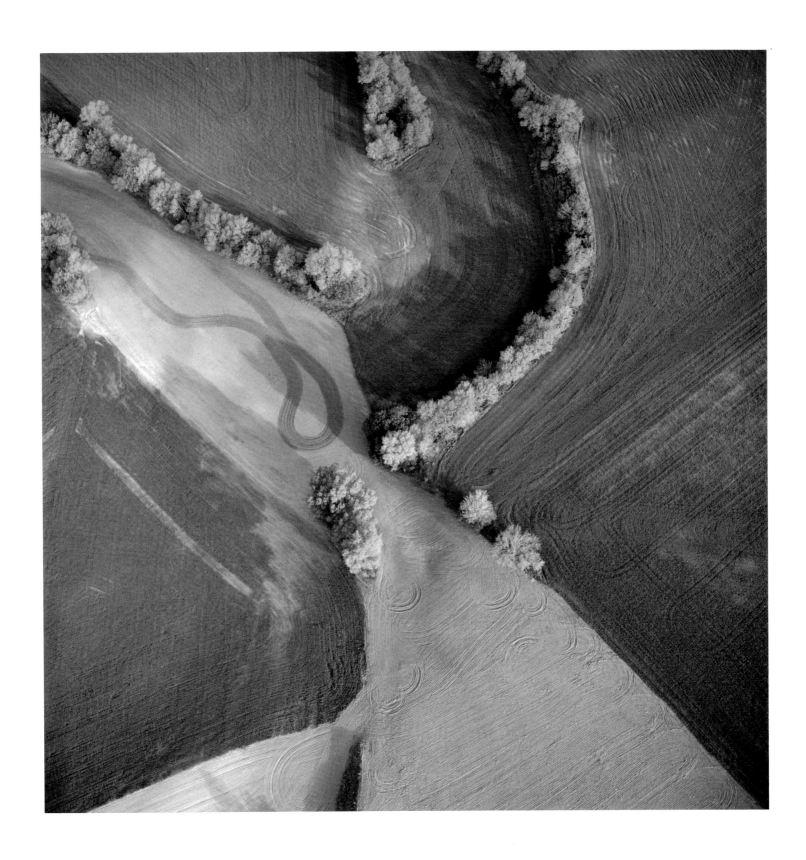

5. Smoky Valley village site, circa 1000 to 1500, Saline County, April 30, 1992.

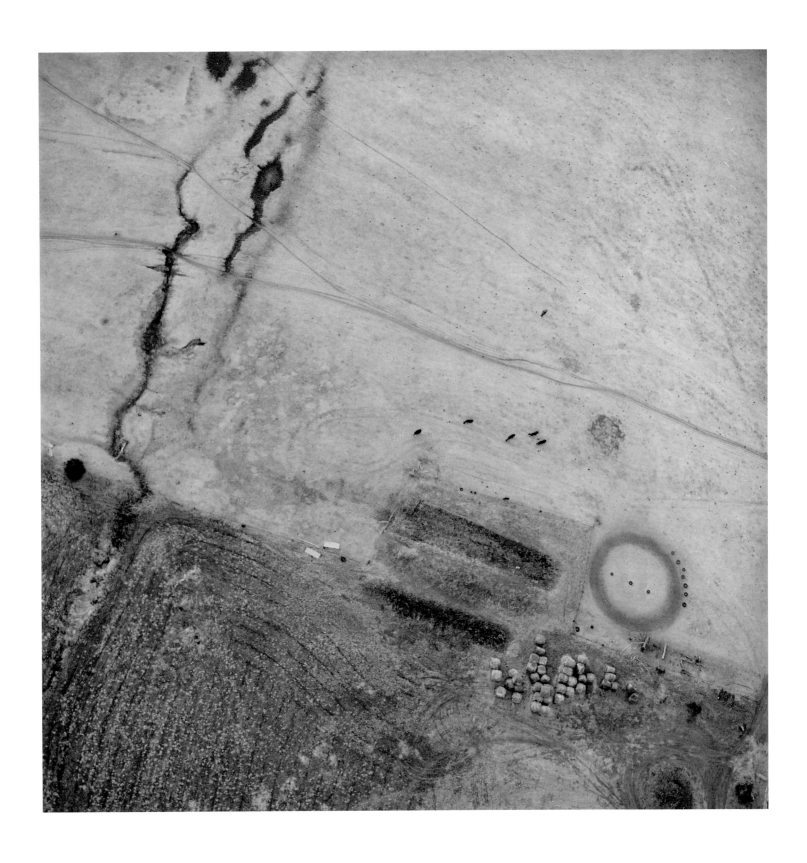

6. Circle with tires and cattle, Saline County, February 13, 1991.

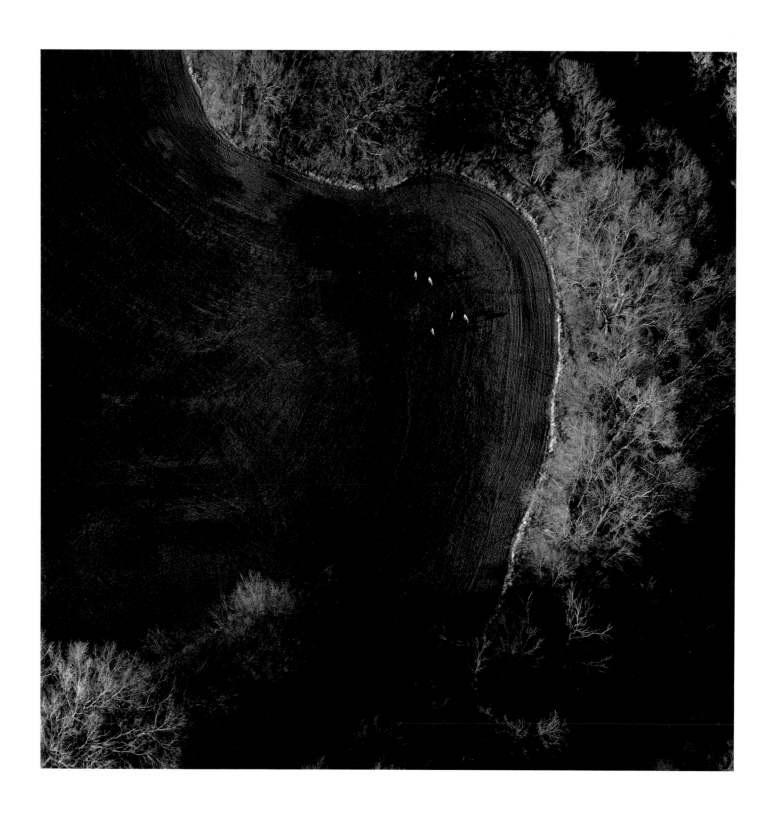

7. Deer grazing on new winter wheat, Saline County, March 1990.

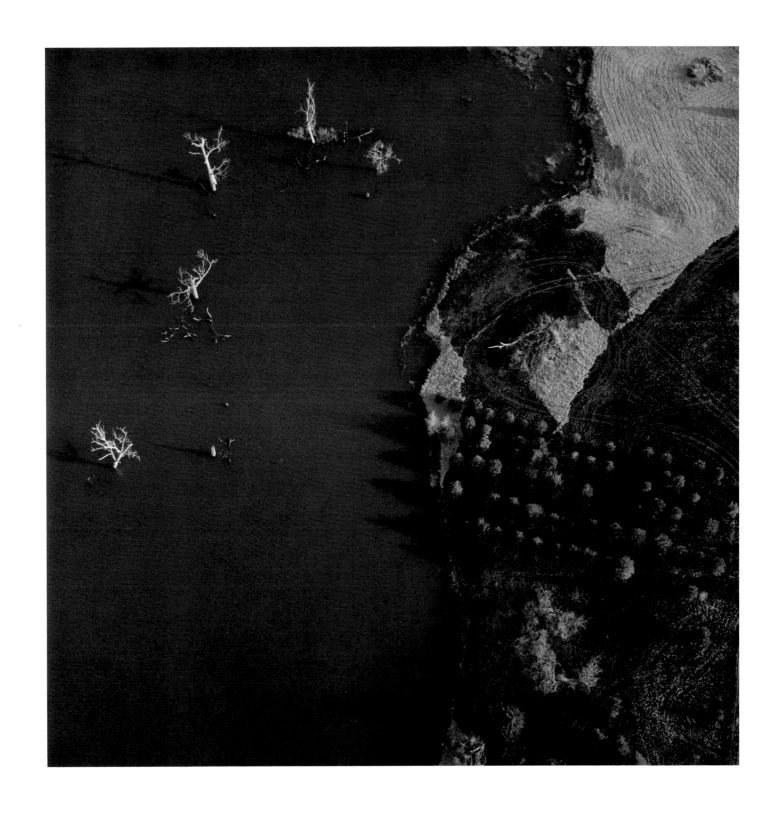

8. Pond with trees, Ottawa County, March 25, 1993.

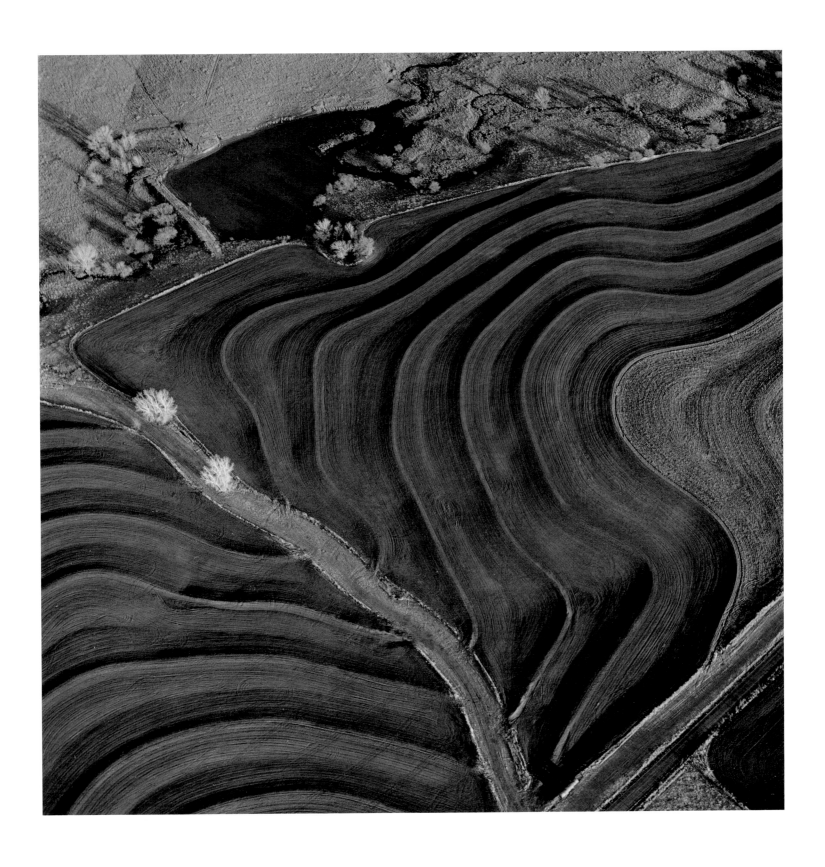

9. Terraced plowing and grass waterway, Saline County, April 18, 1991.

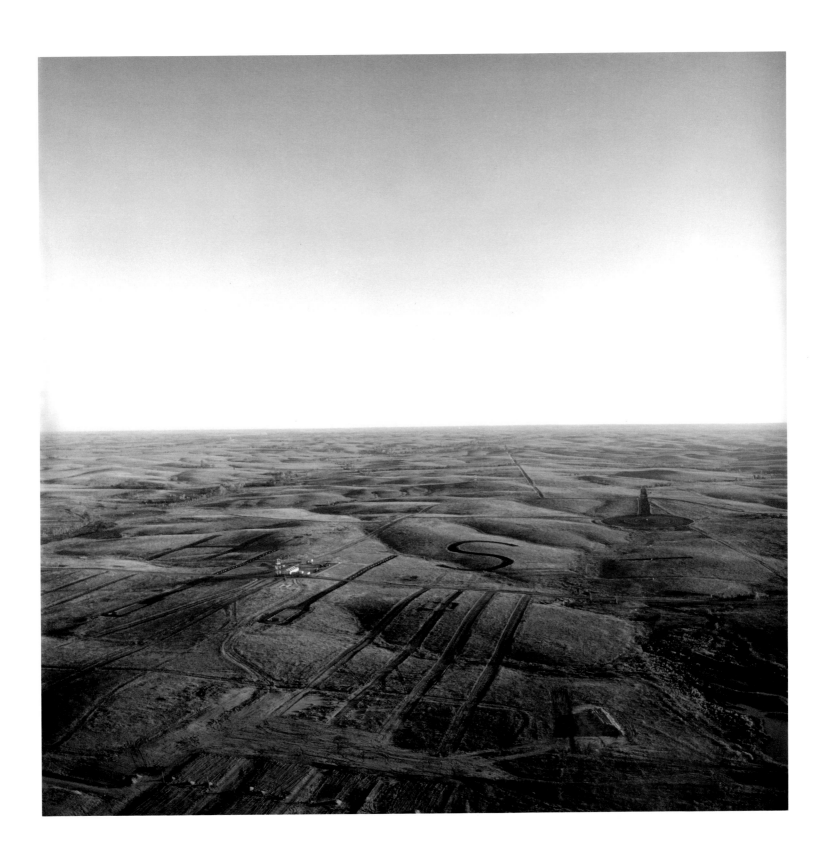

10. Smoky Hill Weapons Range, Saline County, October 22, 1990.

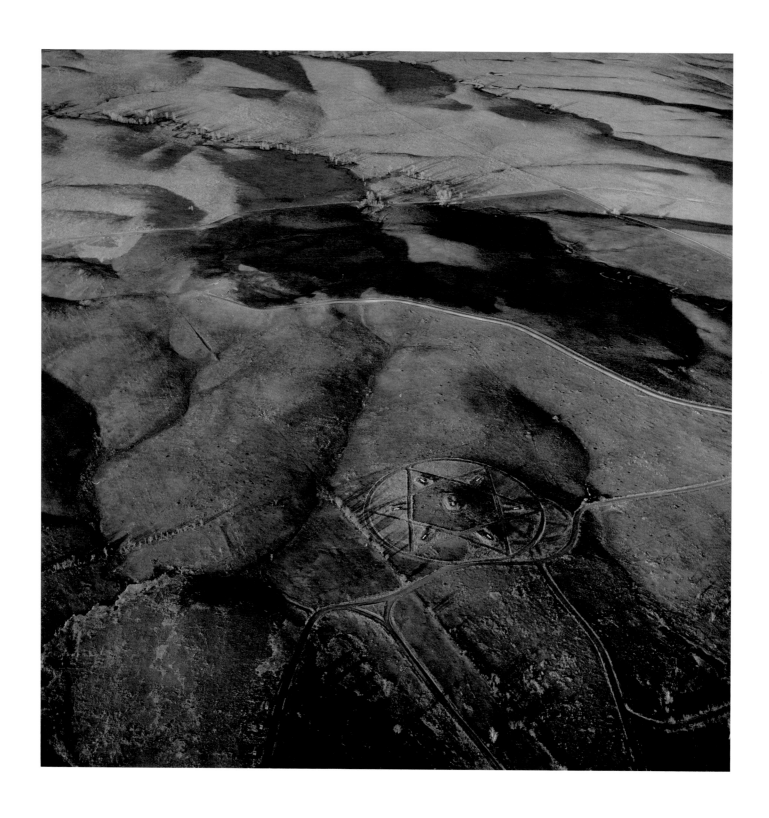

11. Smoky Hill Weapons Range target: Star of David, February 19, 1991.

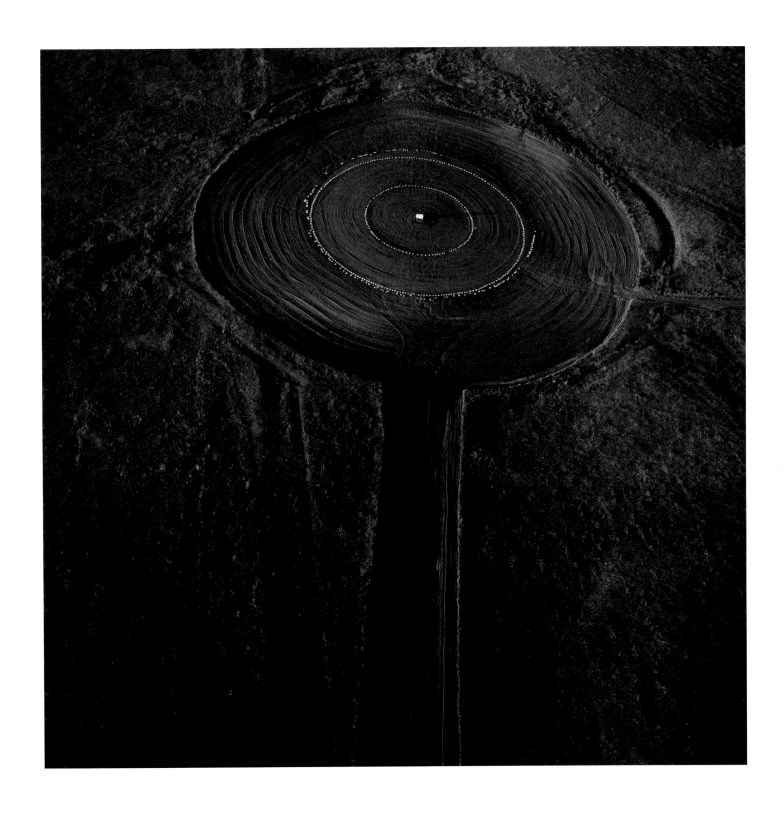

12. Smoky Hill Weapons Range target: tires, September 30, 1990.

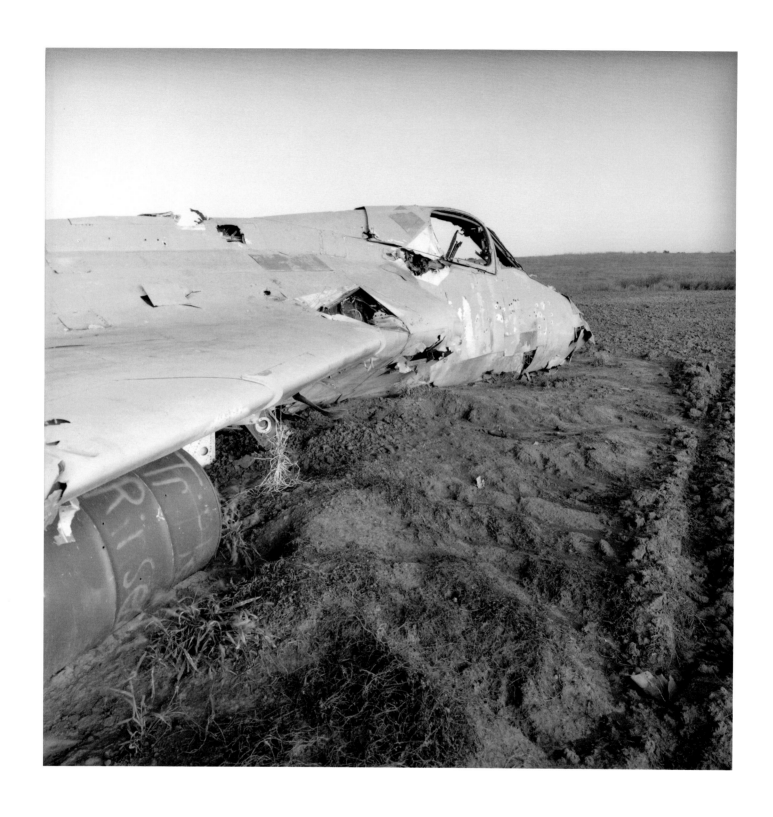

13. Wrecked plane, now target at Smoky Hill Weapons Range, September 24, 1992.

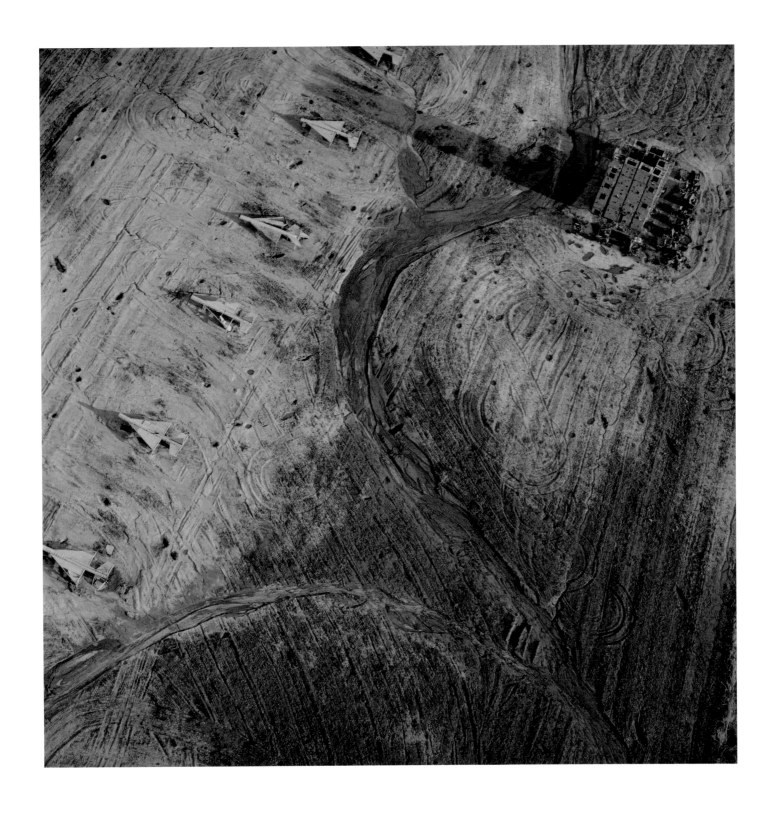

14. Smoky Hill Weapons Range targets: simulated planes, April 11, 1993.

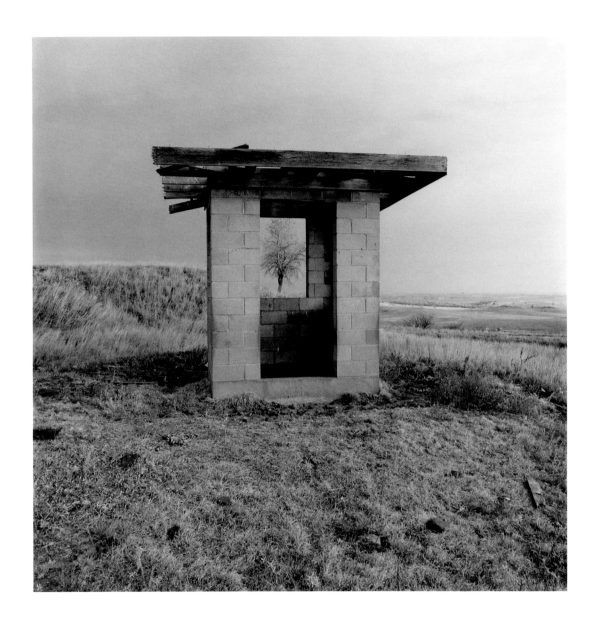

15. Abandoned guard house at missile silo site near Bennington, Ottawa County, November 2, 1990.

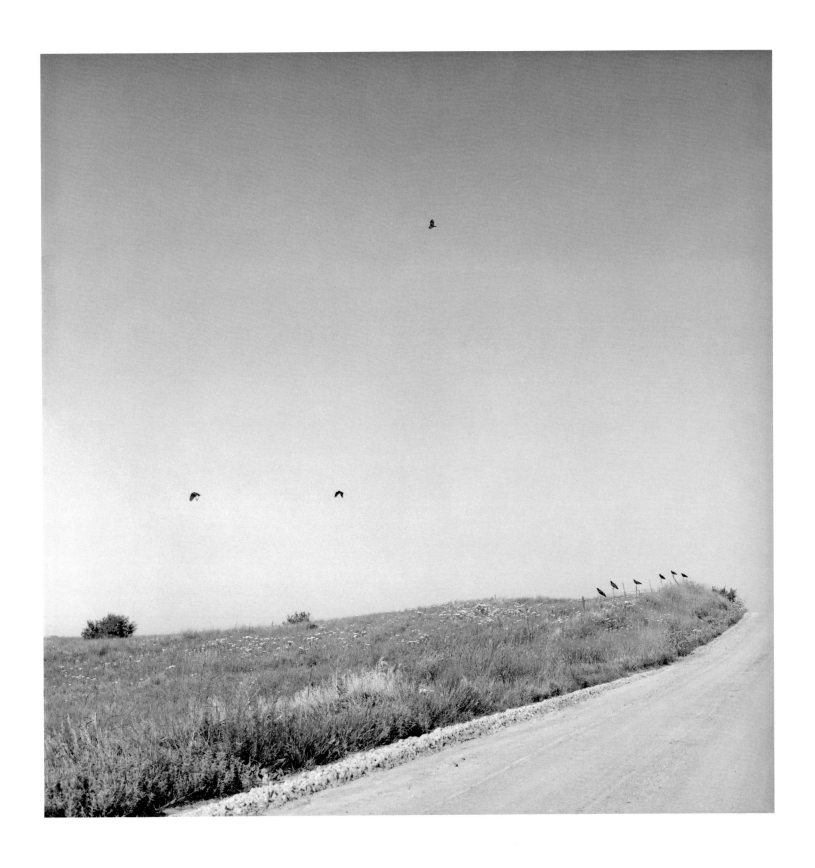

16. Turkey vultures, Ellsworth County, August 16, 1992.

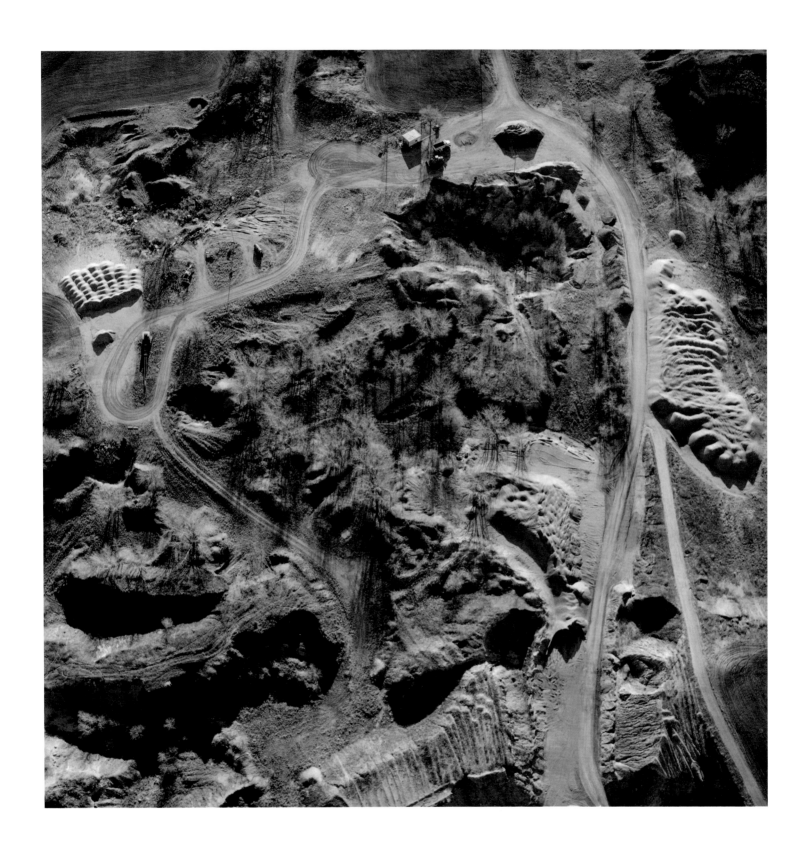

17. Gravel pit, McPherson County, March 23, 1991.

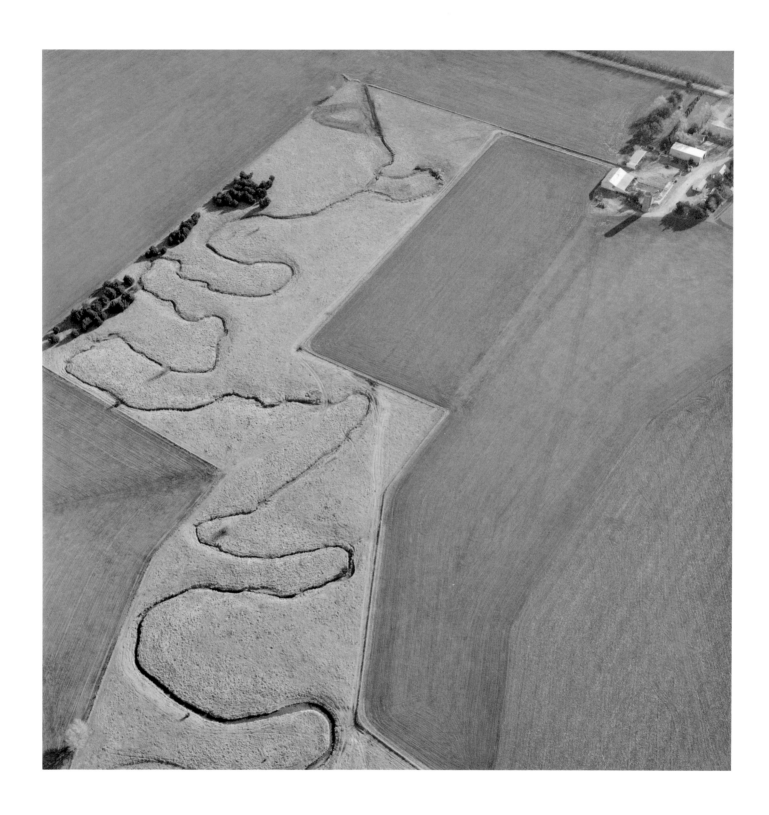

18. Former wetland drained for farming in 1911, McPherson County, March 23, 1991.

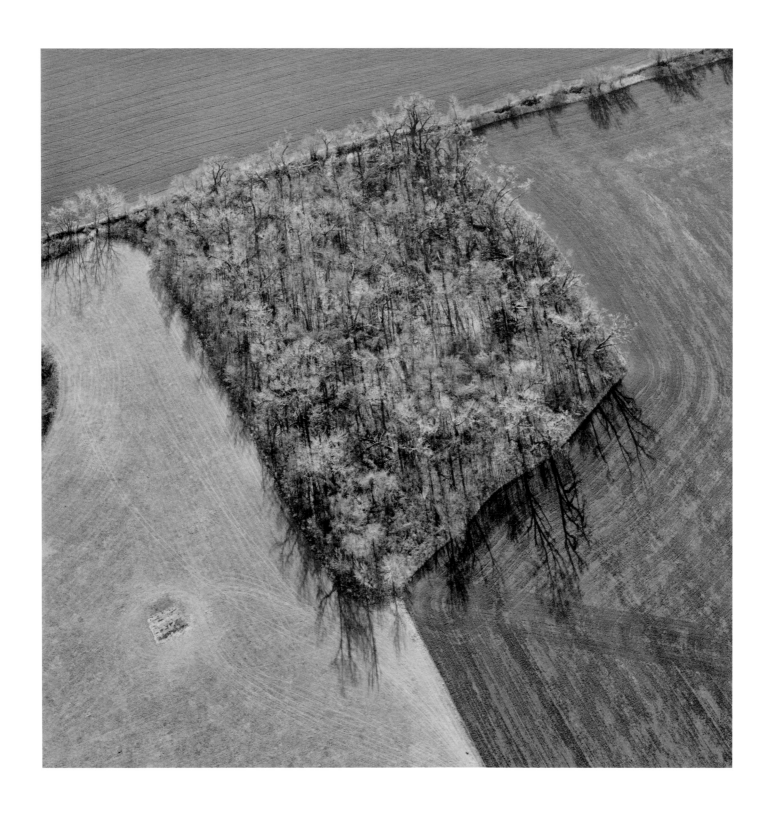

19. Woodlot and abandoned road, McPherson County, March 23, 1991.

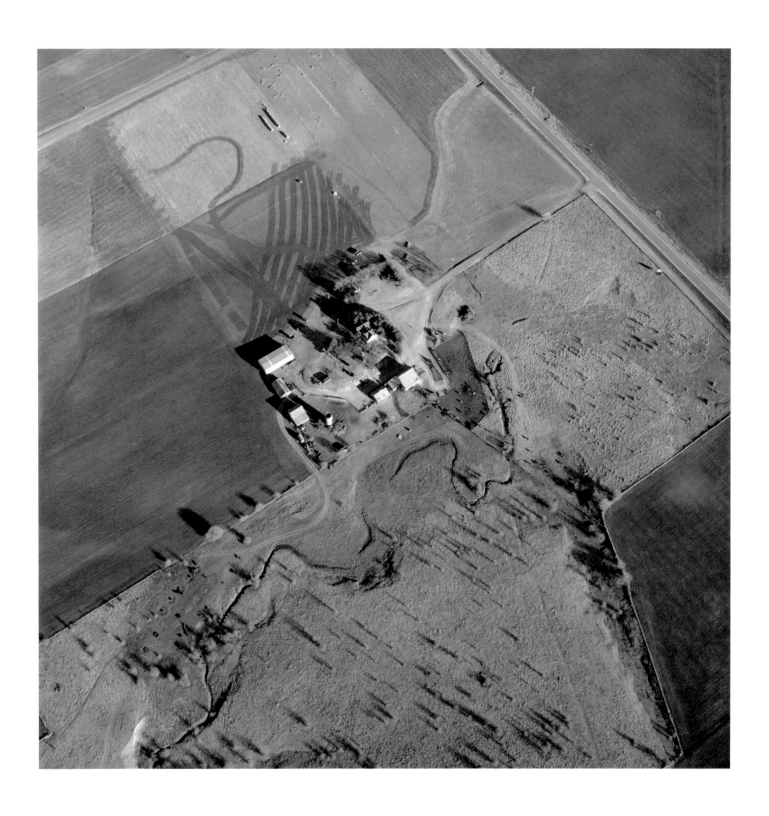

20. Farm, McPherson County, March 4, 1991.

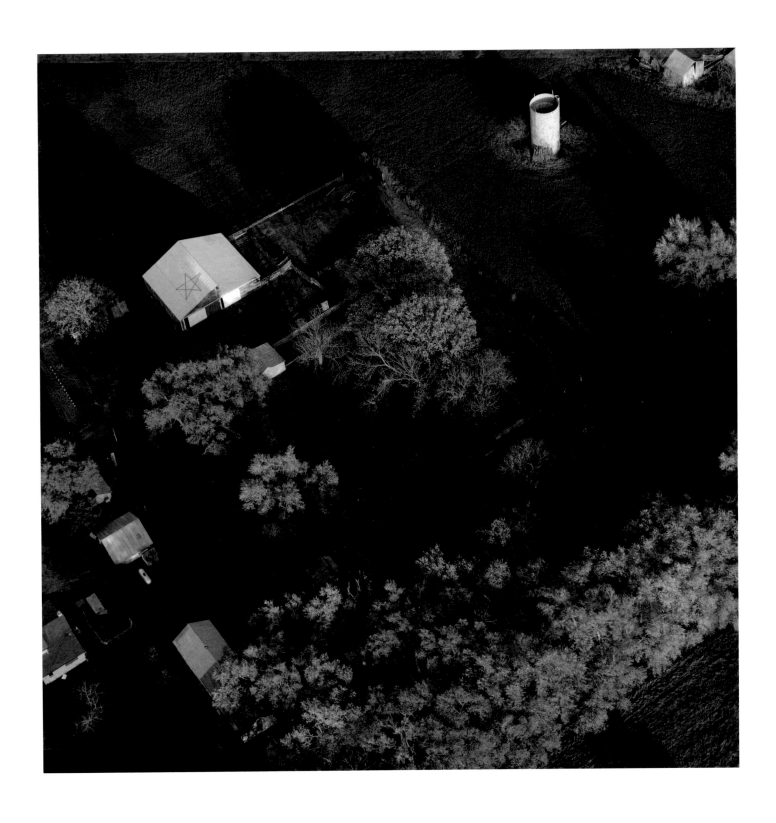

21. Farm, Saline County, May 3, 1993.

22. Wheat field just north of White Cross Nursing Home hill, May 21, 1992.

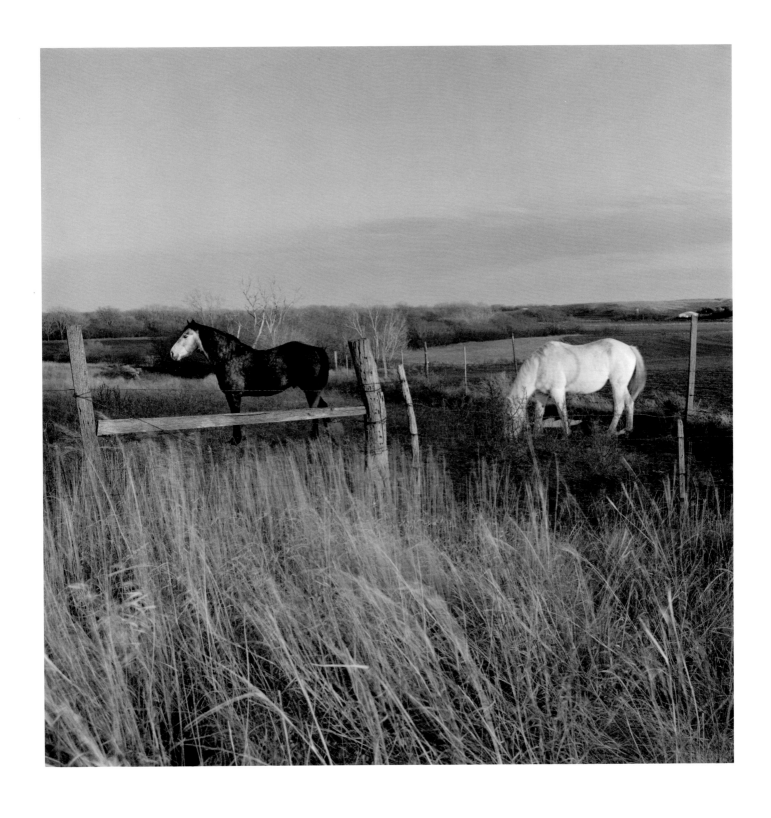

23. Two horses, Ottawa County, December 1992.

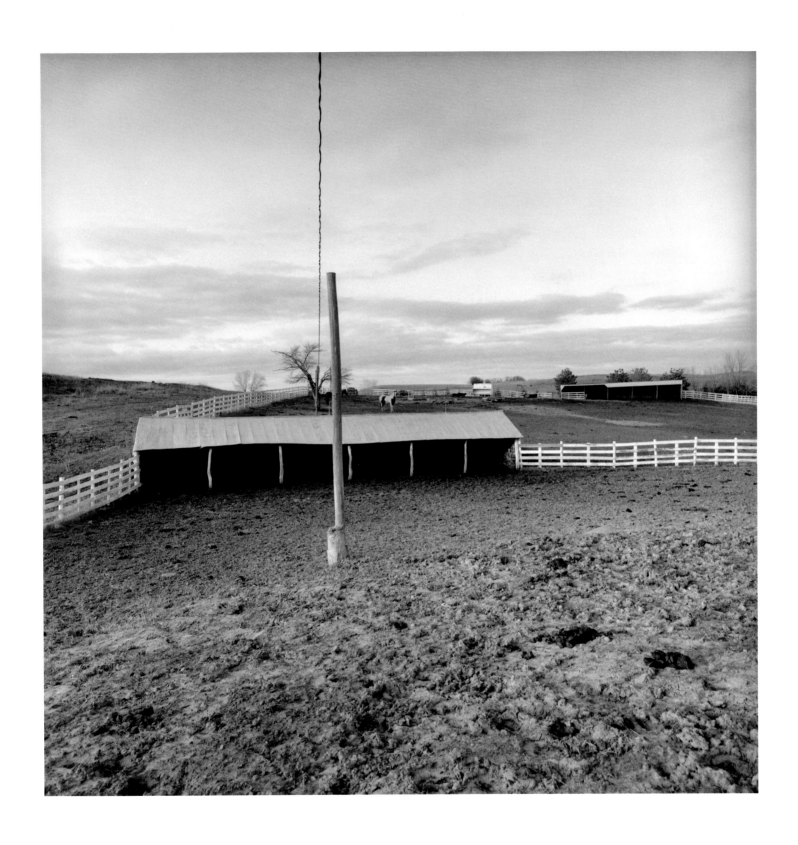

24. Evans farm, Ottawa County, January 18, 1992.

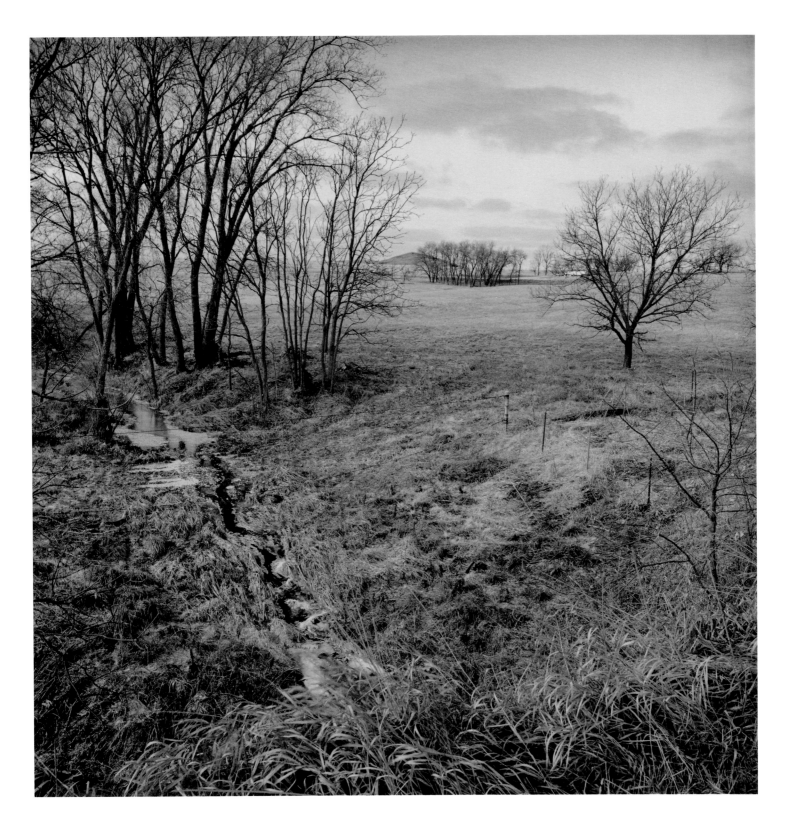

25., 26. Looking west from Old Highway 81, Ottawa County, December 1992.

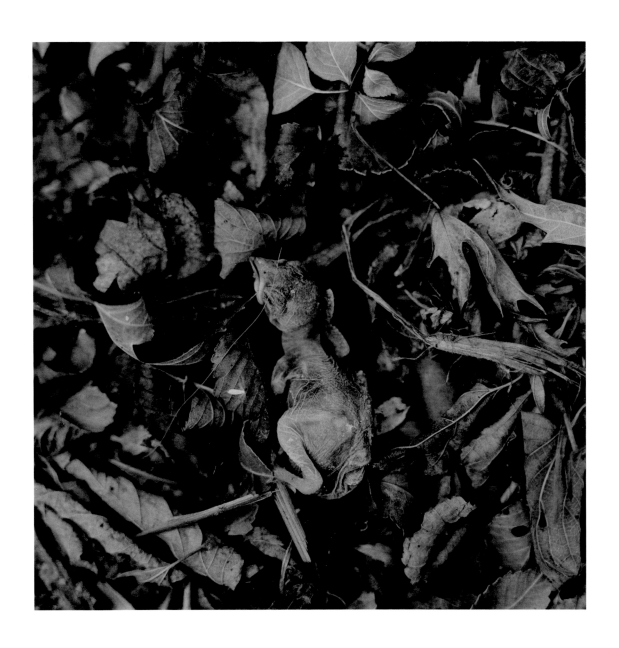

27. Spring, Salina, May 1992.

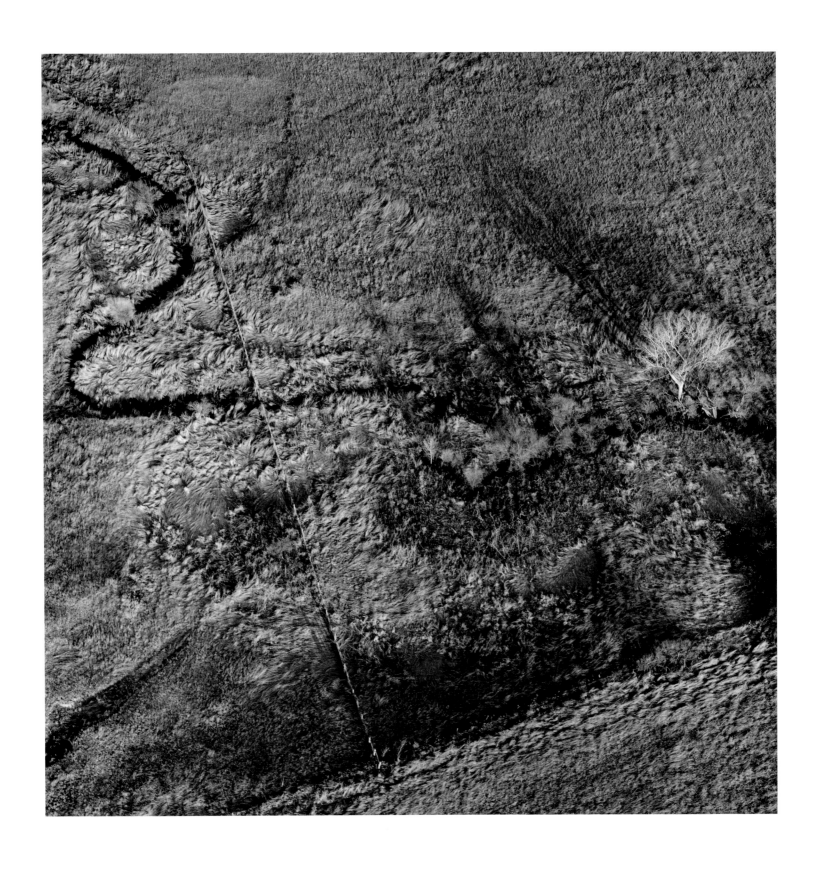

28. The Land Institute, Salina, March 24, 1993.

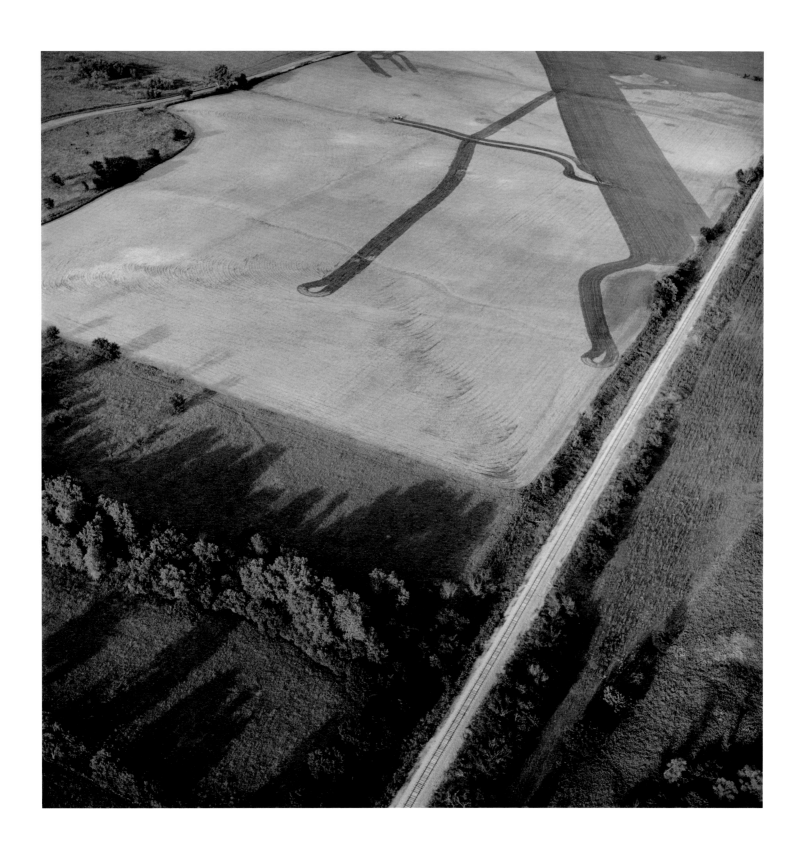

29. Tracks, north central Kansas, August 23, 1990.

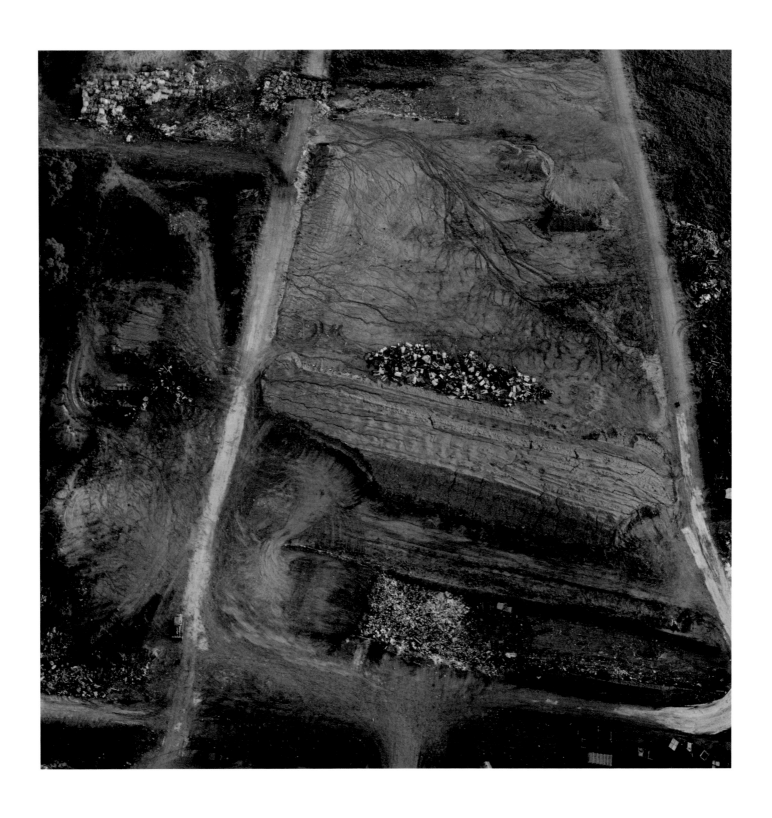

30. Landfill, McPherson County, July 1991.

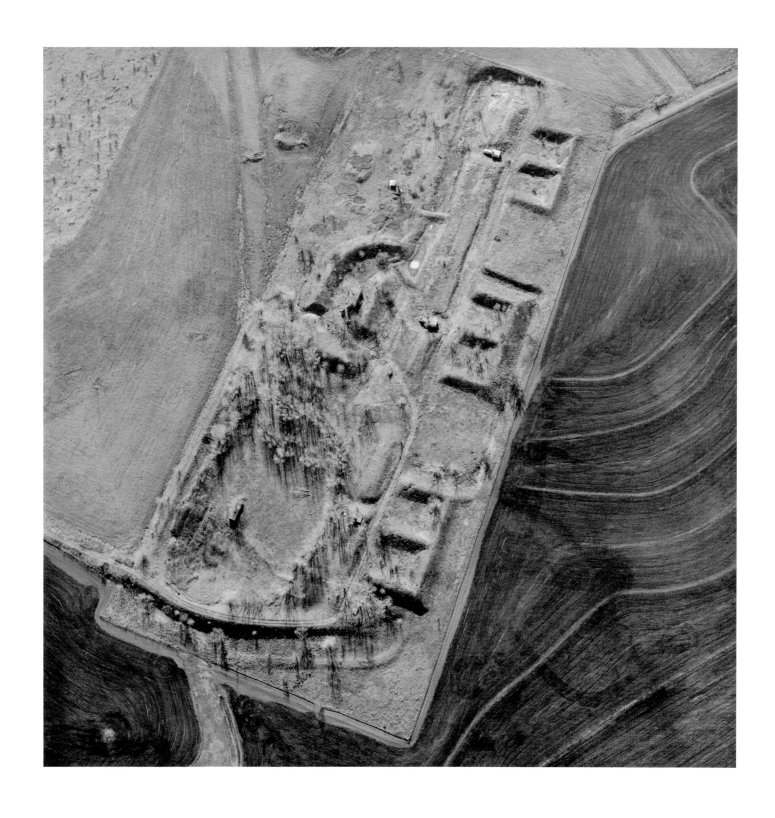

31. Abandoned missile launching pad, Saline County, March 23, 1991.

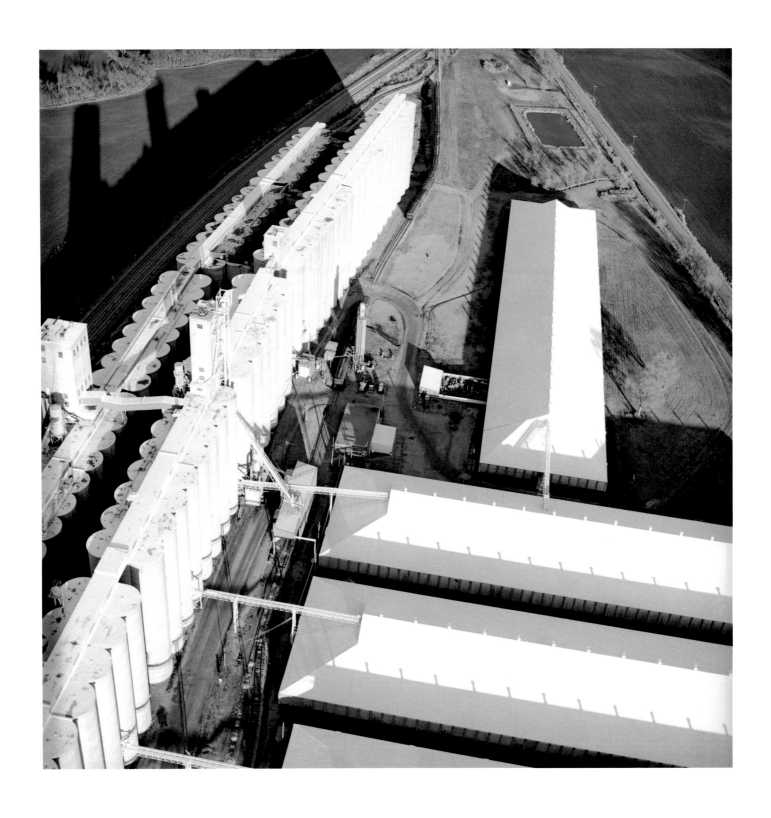

32. Bunge grain storage terminals, Salina, April 18, 1991.

33. Natural gas storage, McPherson County, April 1991.

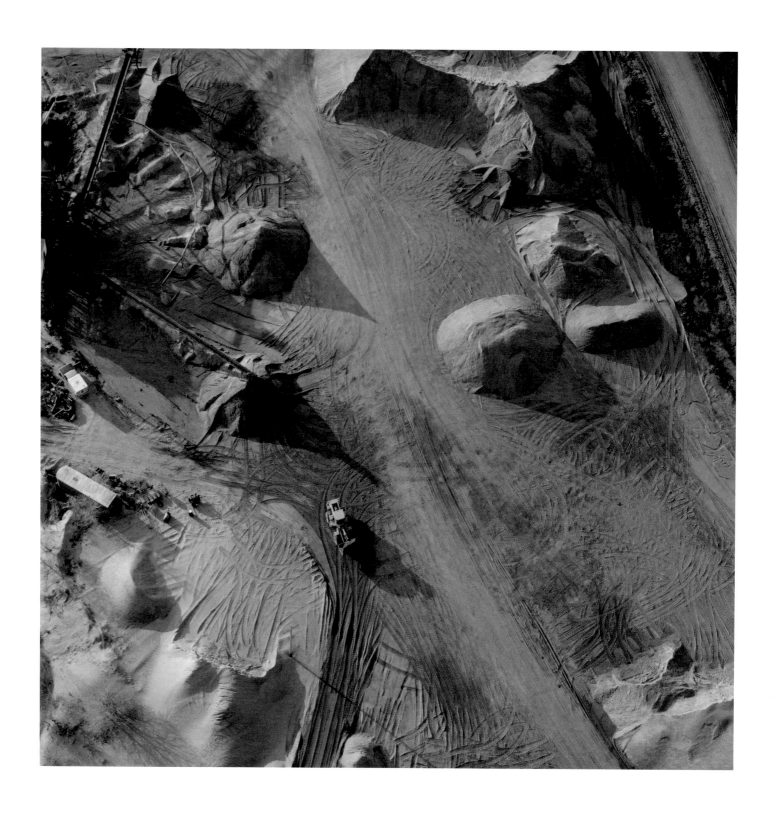

34. Sandpit, Salina, April 24, 1993.

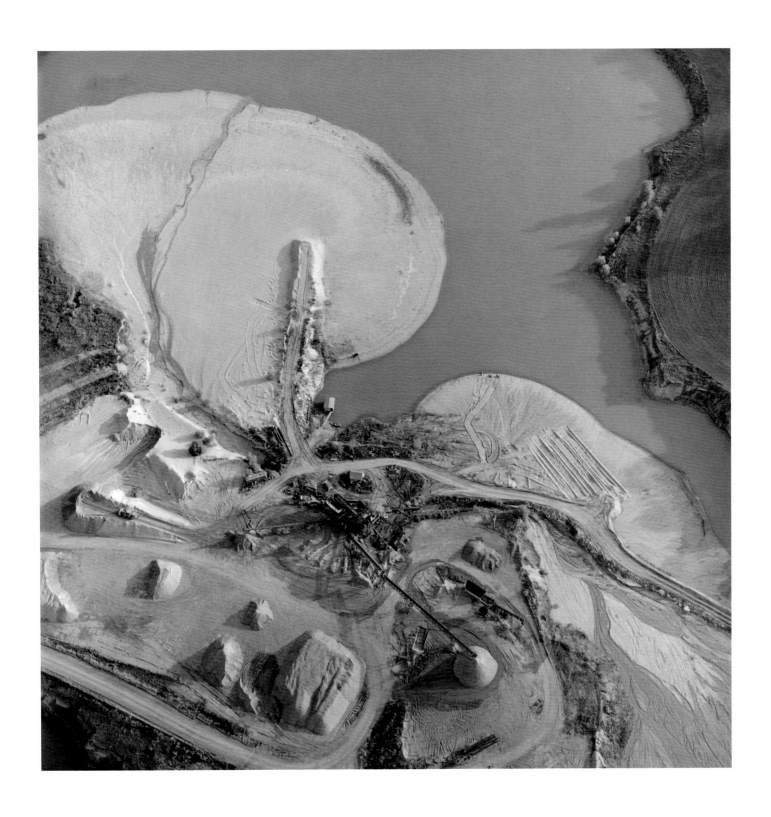

35. Sandpit, Salina, May 1993.

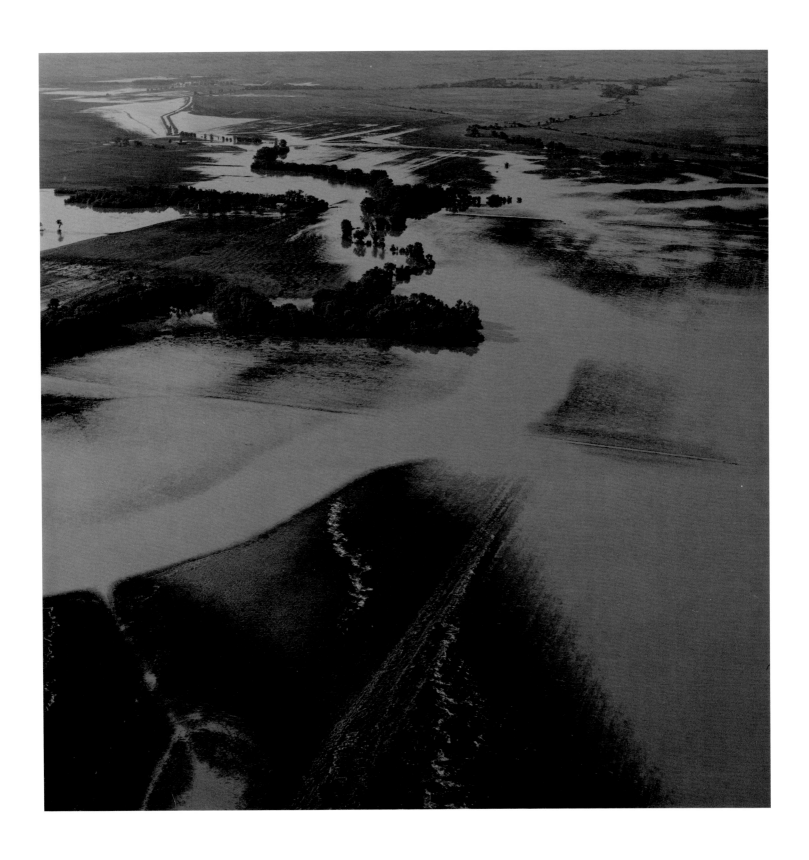

36. Flooding from Solomon River, July 23, 1993.

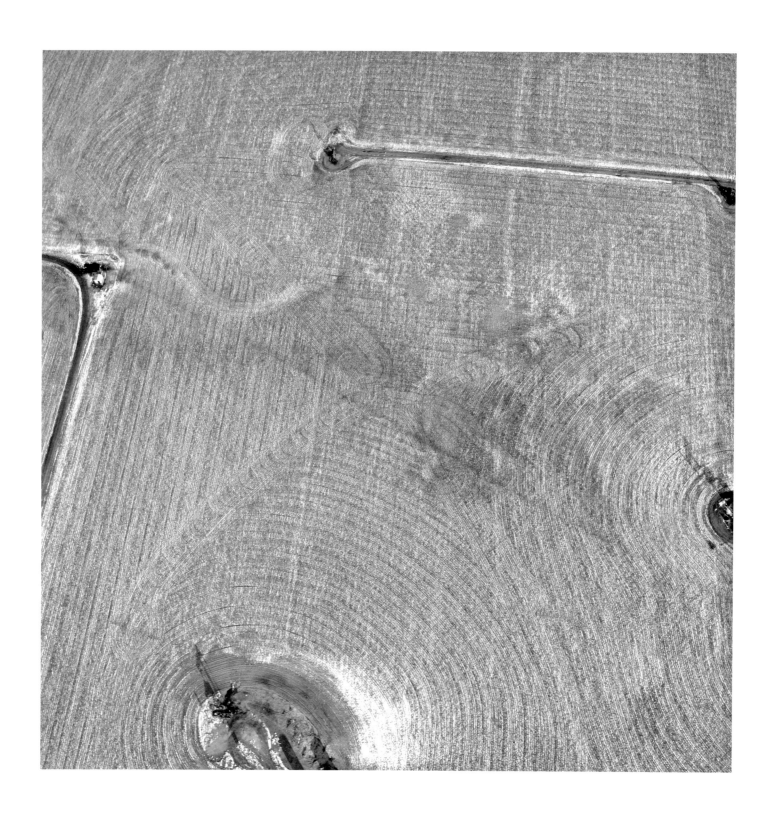

37. Oil pumping jacks in wheat field, McPherson County, December 22, 1990.

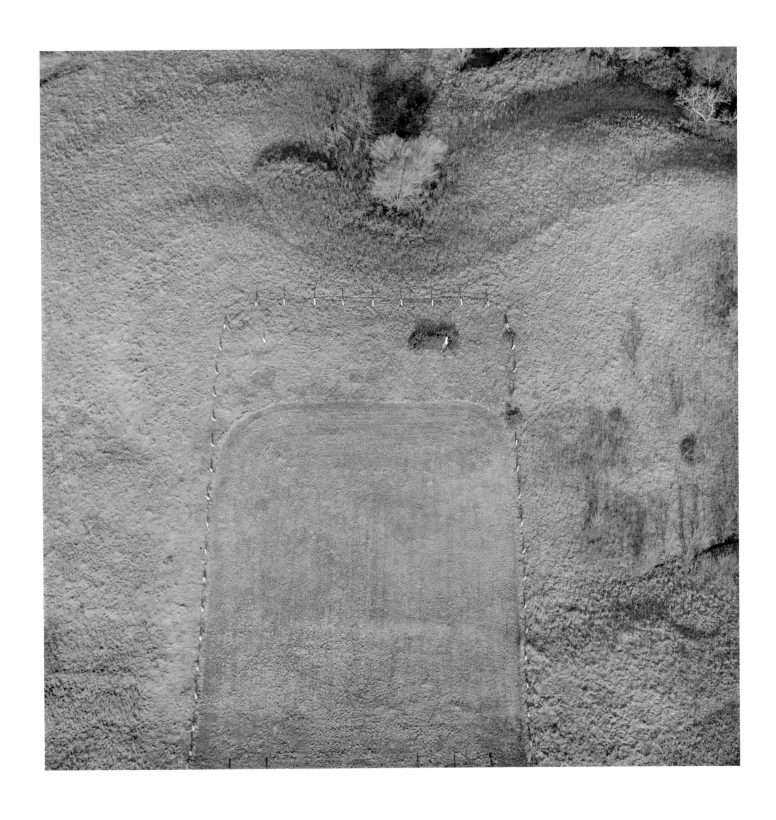

38. Two graves, Saline County, April 24, 1993.

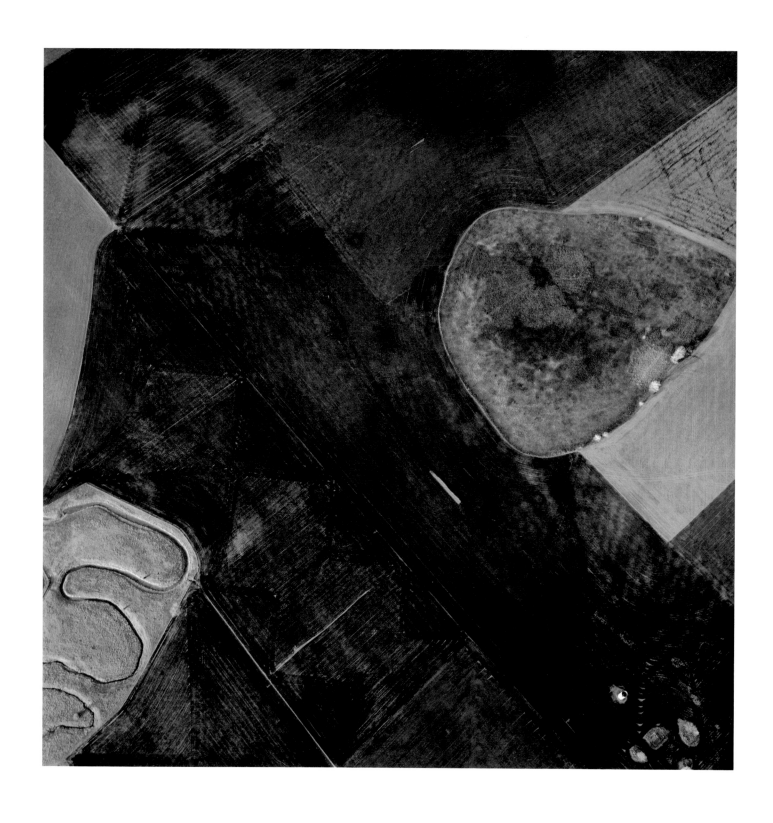

39. Natural wetland drained for farming in 1911, McPherson County, April 2, 1991.

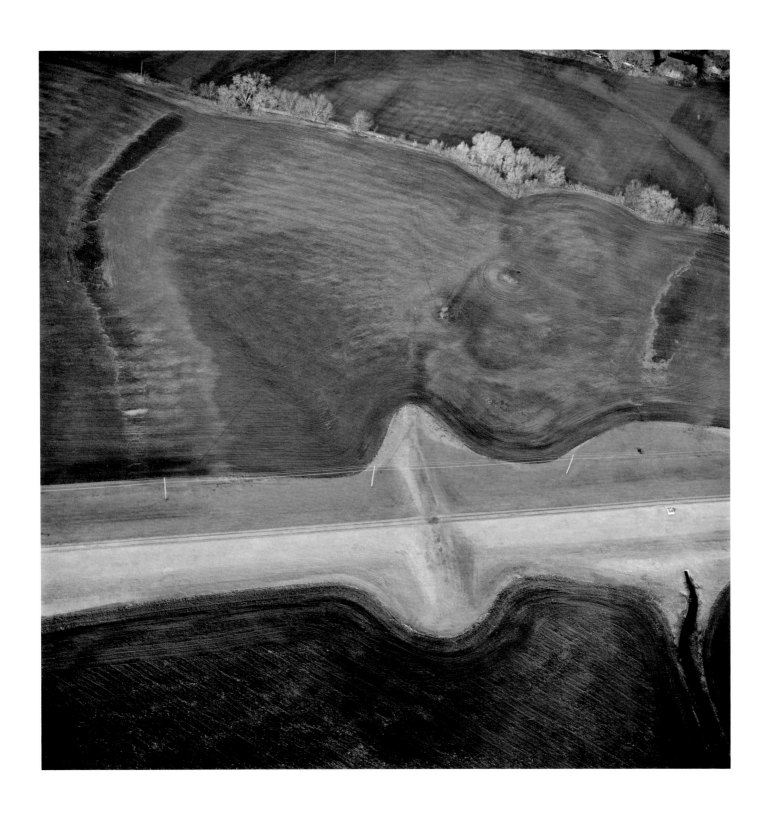

40. Flood control dike, Salina, March 8, 1993.

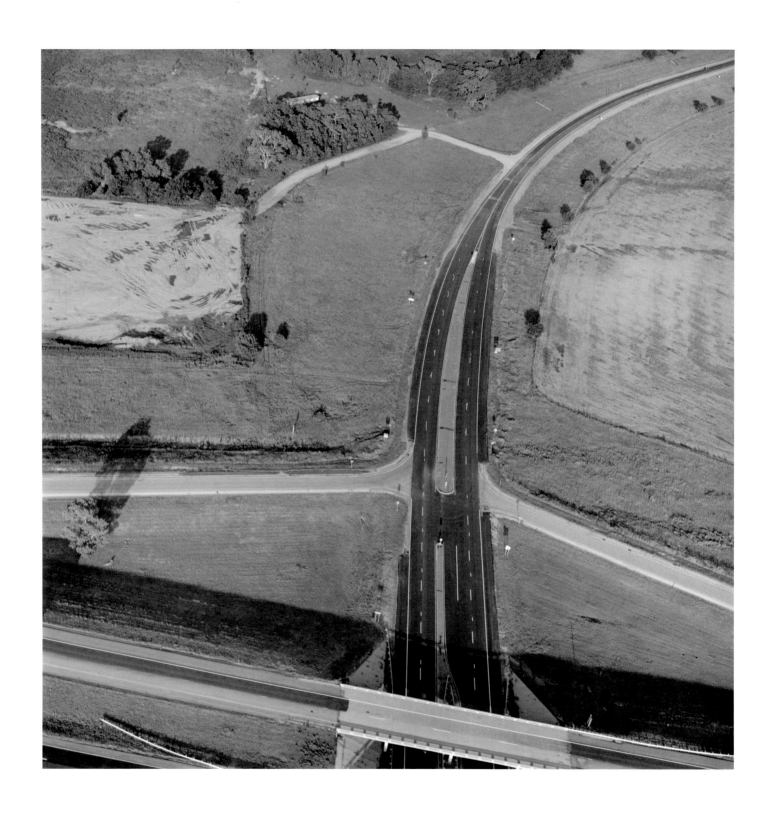

41. Interstate 35 at Salina, July 31, 1992.

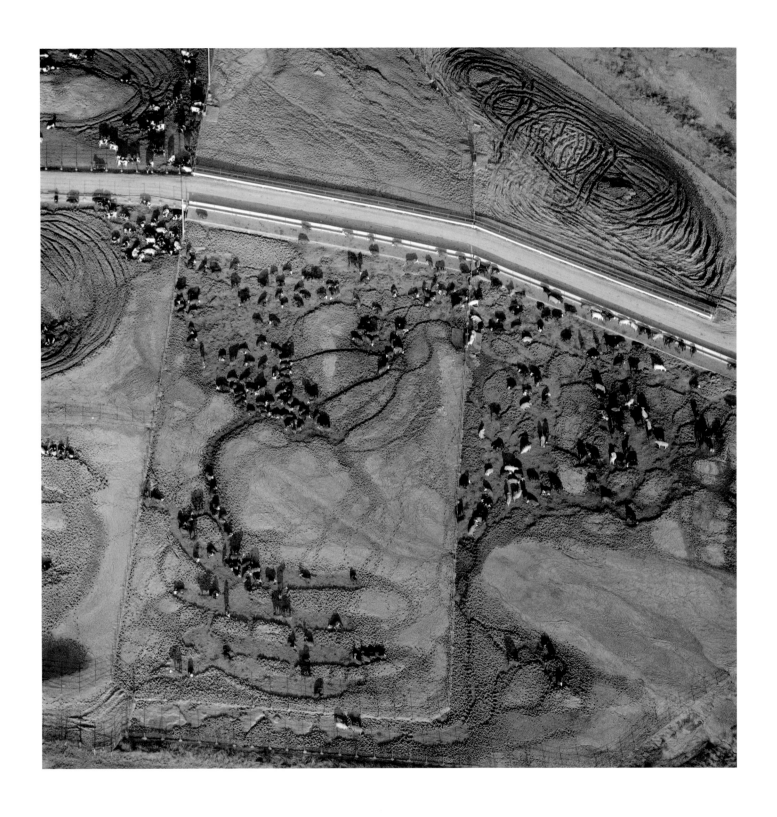

42. Cattle feedlot, Saline County, April 24, 1993.

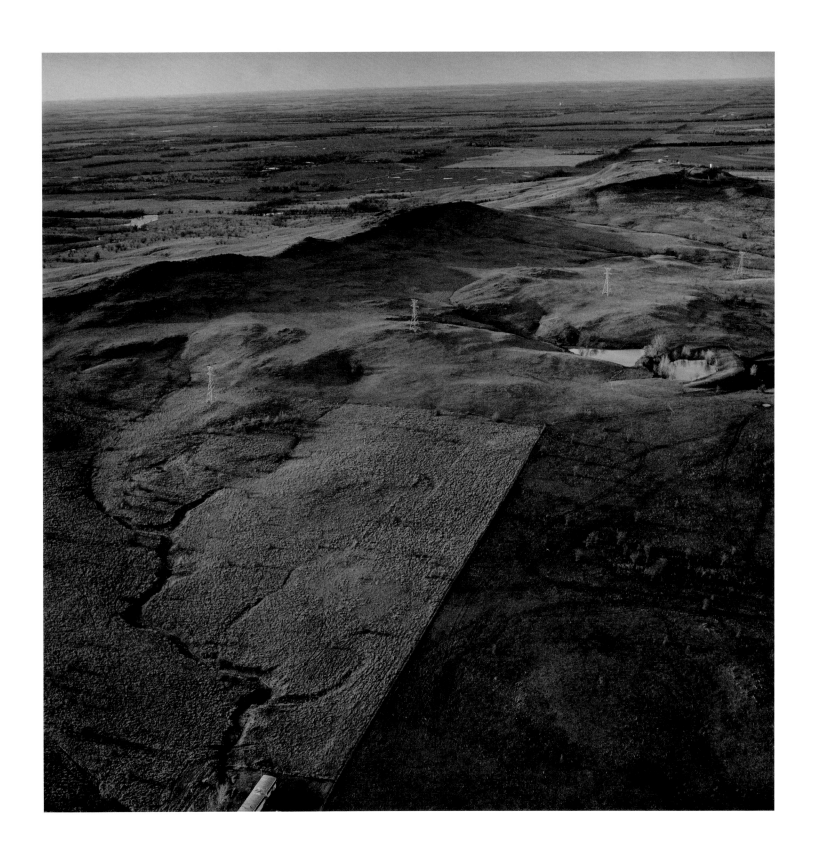

43. Smoky Hills, Saline County, April 9, 1993.

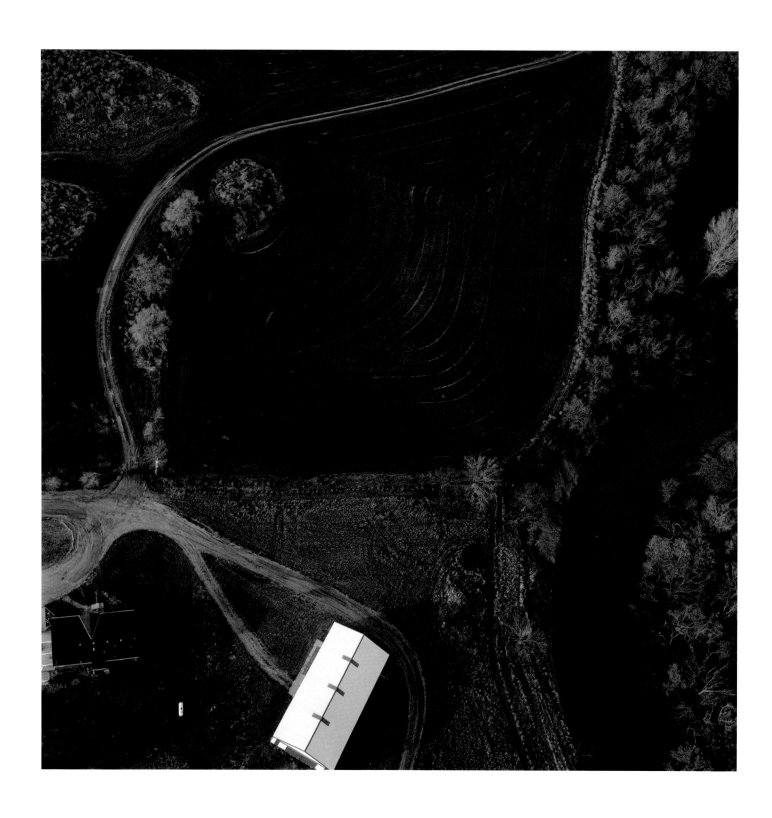

44. Three sites, April 24, 1993.

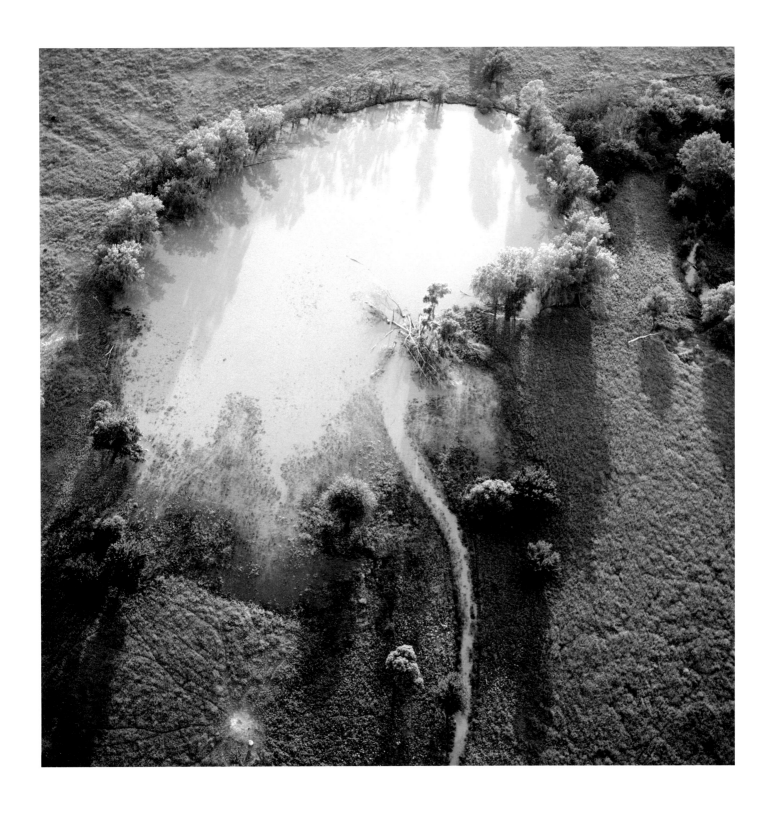

45. Pond north of Salina, August 23, 1990.

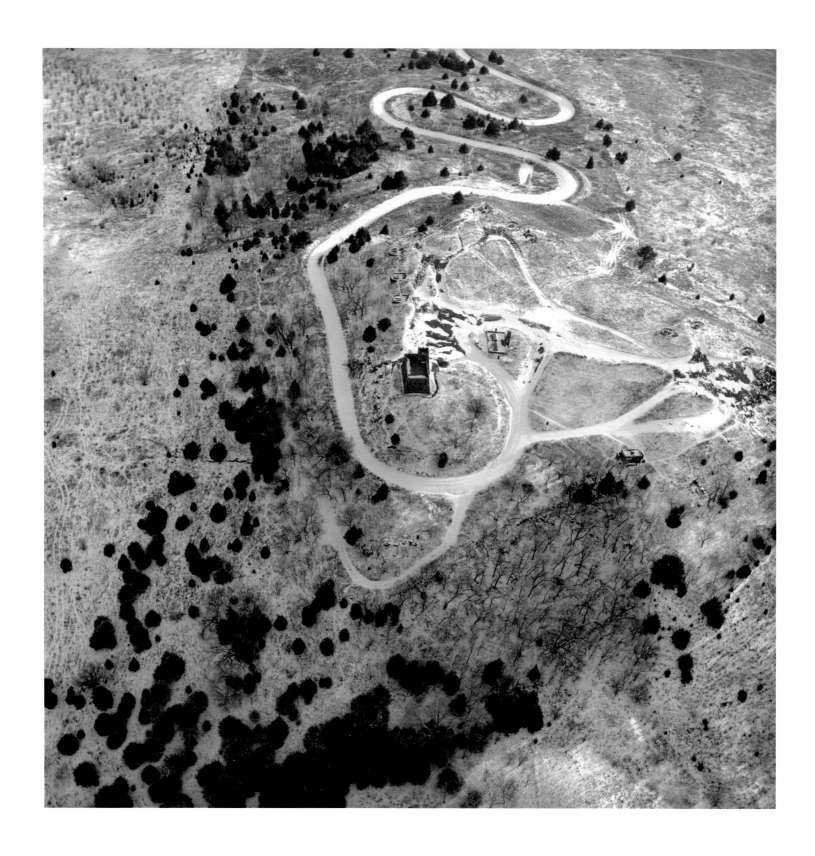

46. Coronado Heights, Lindsborg, January 25, 1991.

47. Cedar tree at Crown Point Cemetery, Ottawa County, October 5, 1992.

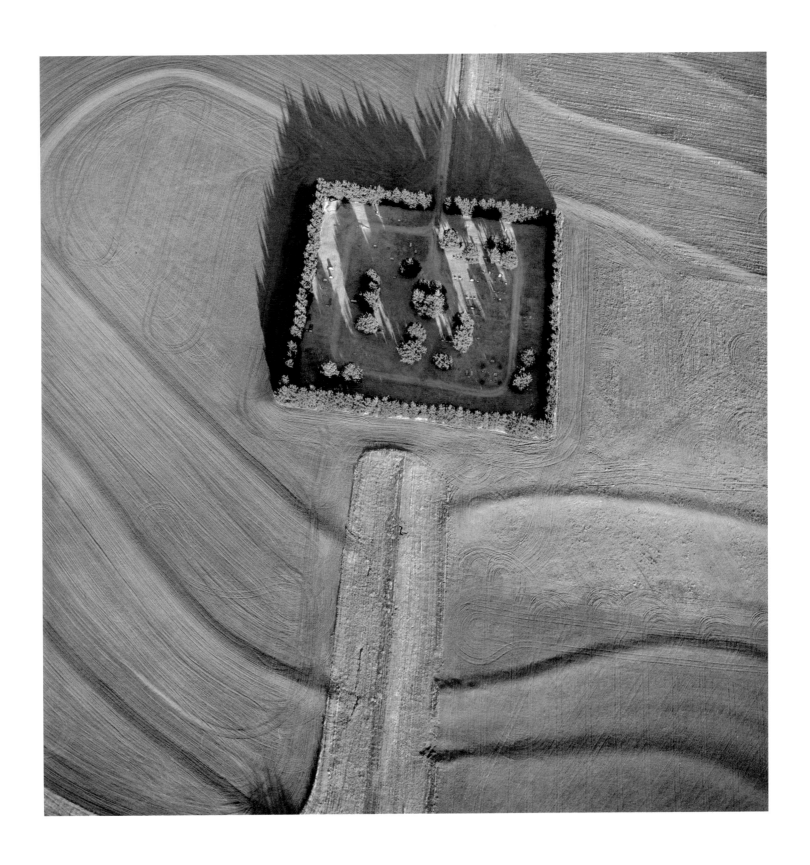

48. Rose Hill Cemetery, Saline County, February 19, 1991.

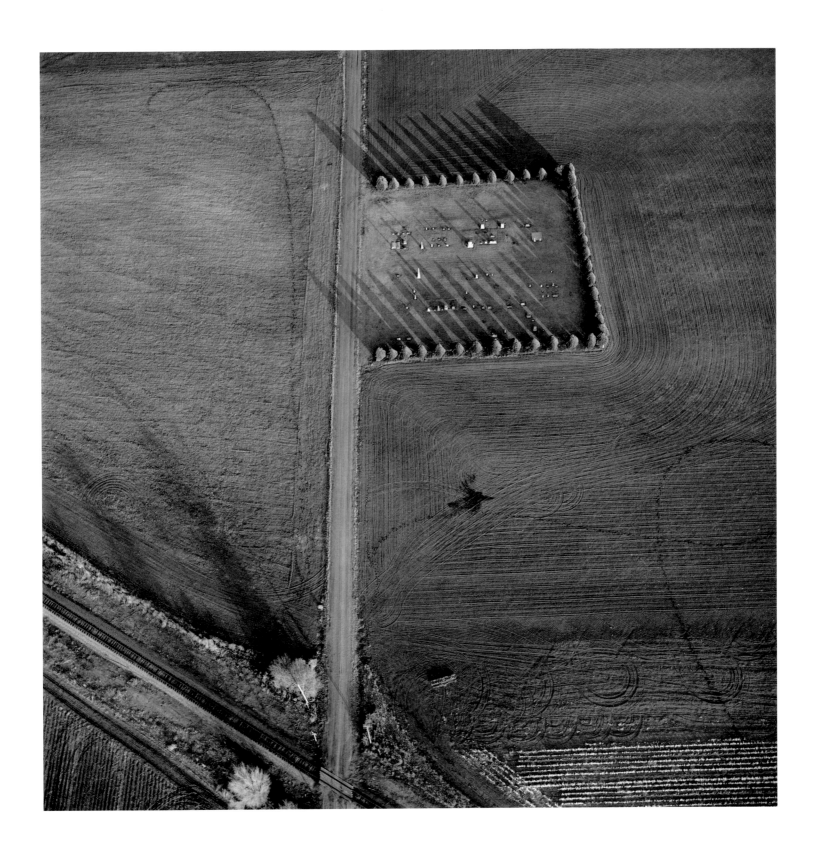

49. Assaria Cemetery, Saline County, January 20, 1992.

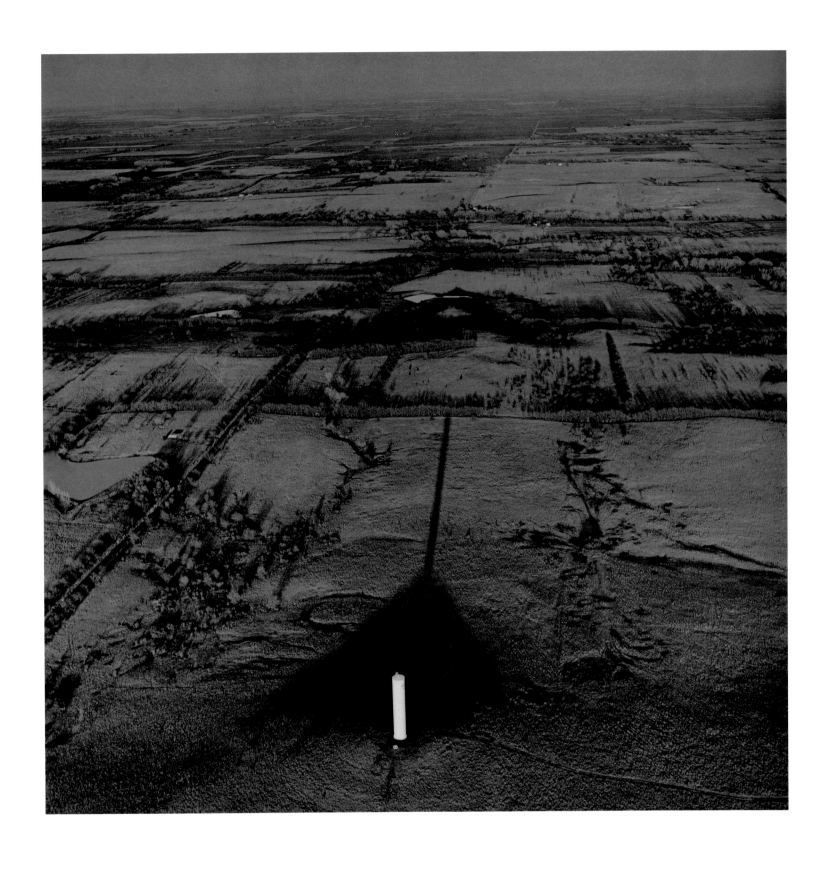

50. Tower for Saline County, Kansas Water District #2, April 18, 1991.

NOTES ON THE PHOTOGRAPHS

1. Solomon River oxbow, August 2, 1990. If we looked at this place now, or probably even a week after the photo was taken, the circle of water would be drained away, but in this moment, it shows the former course of the river.

5. Smoky Valley village site, circa 1000 to 1500, Saline County, April 30, 1992. The village site was just east of the curve of trees (right side of the photograph) when the Smoky Hill River ran between the trees. The land now belongs to Kenneth and Leibert Johnson.

7. Deer grazing on new winter wheat, Saline County, March 1990. There is a line between the domesticated field and the wild woods, but the deer have crossed the boundary, erasing it in the process.

11. Smoky Hill Weapons Range target: Star of David, February 19, 1991. Disconcerting, this target replicates an old Russian design of a launch site of surface-to-air missiles. United States reconnaissance planes identified similar sites on the coast of Cuba during the 1961 Bay of Pigs invasion.

12. Smoky Hill Weapons Range target: tires, September 30, 1990. White tires surround the two inner circles.

17. Gravel pit, McPherson County, March 23, 1991. My observation shows that in contrast to sandpits, which seem to resemble each other due to the requirements of the machinery used to extract sand, gravel pits each have their own unique shape, idiosyncratic perhaps to both the natural site and the owner's sense of design.

20. Farm, McPherson County, March 4, 1991. After wondering about those tractor lines for years, it finally occured to me that the tractor was probably parked out in the field to start with, and the farmer made that nice curve bringing in the tractor to begin going across the field. Maybe the farmer was tamping down the dirt to protect it from blowing in March winds.

24. Evans Farm, Ottawa County, January 18, 1992. I like the scale of this picture. Our neighbor's horse is about the same distance from my eye as the land is at my usual aerial perspective of around 700 feet altitude.

25. & 26. Looking west from Old Highway 81, Ottawa County, December 1992. According to Bud Sullivan, this land has been in the Lydia Srack family for generations and was broken out in the 1950s. Bud worked there, farming it for milo from 1961 to 1964. In the 1970s, it was planted back to native grass.

29. Tracks, north central Kansas, August 23, 1990. These tractor markings remind me of prehistoric cave drawings, or petroglyphs. "Wheat glyphs," Mark Klett called them.

37. Oil pumping jacks in wheat field, McPherson County, December 22, 1990. At this site, the land is mined for wheat above the ground and for oil below the surface. The snow dusting reveals information, like dusting for fingerprints.

44. Three sites, April 24, 1993. Along the curve of the field next to the river, I found a stone scraper, presumably made by early Smoky Valley people. Up on the curve of the field by the trees and road, I found old pieces of slate, porcelain, and glass left by European settlers. Now we see the house and barn of the current inhabitants.

46. Coronado Heights, Lindsborg, January 25, 1991. The park was built as a WPA project in 1936 to commemorate the northernmost point penetrated by Coronado's expedition in 1541. While Coronado is only known to have gone as far as Quivera, Wes Jackson speculates that he probably could not resist continuing on to the hill we call Coronado Heights and looking off the top of it.

49. Assaria Cemetery, Saline County, January 20, 1992. The calligraphic curves in the field were made by a single deer, each hoof print plainly visible with a magnifying glass. Aerial photographs usually contain more visual information than is immediately accessible to the eye.

50. Tower for Saline County, Kansas Water District #2, April 18, 1991. I'm told that since this tower is close to the Ottawa County line, users from both counties claim water rights. There are layers of human stories in each of these pictures, just as there are layers of visual information.

ACKNOWLEDGMENTS

THIS BOOK comes not only from the land and landscape but also from the encouragement and support of Salinans who lived there and who live there now.

Dean Evans, my father-in-law, showed me community commitment that continues to teach me. His generosity has infused the life of Salina, Kansas, beyond measure. Grace Evans, my mother-in-law, welcoming grandmother on the next block, made it possible for me to weave together photography and family.

The following people carry on Grace and Dean's dedication to community, each in their own ways, and without them, this book would not exist. I am deeply grateful to Becky and Milton Morrison, Paula Fried and Brad Stuewe, Jan and Tom Wilson, Harris and Shannon Rayl, the *Salina Journal*, Mike Berkley, the Bennington State Bank, Merle and Nancy Hodges, George and Jean Frisbie, Bill and Helen Graves, the law firm of Hampton, Royce, Engleman and Nelson, Amanda and Jerry Gutierrez, Ann and Jack Parr, Randy and Saralyn Hardy, Cynthia Campbell, and George Jerkovich.

For helping me think about the complex weave of place, prairie, community, and art, I thank my friends Wes Jackson, Saralyn Reece Hardy, Mary Kay, Frank Shaw, Donald Worster, and Brian Donahue.

I'm indebted to my friend and colleague Greg Conniff for conversations and insights about almost every aspect of this book.

For thinking about the photographs with me, I'm grateful to Merry Foresta, Mike Hartung, Sandra Phillips, Joel Snyder, Tom Southall, John Szarkowski, David Travis, and the Water in the West group.

Thanks to Bud Sullivan and Harley Elliott for telling me the stories of places in these photographs. I thank Kenneth and Leibert Johnson for conversations about their land. I'm grateful to Alan Thomas for helpful discussions.

I'm deeply in debt to pilots Dwayne Gulker and Jonathan Baxt for generous contributions of their time.

For patience and diligence, I thank the staff of the University Press of Kansas, especially Fred Woodward. I'm grateful to Ed King for design quality.

I'm thankful for the encouragement of my father, Norman Hoyt, photographer, and my mother, Dale Hoyt. Thanks to my son, David Evans, and my daughter, Corey Evans, for invigorating and thoughtful responses to this work. Finally, I am especially grateful to my husband, Sam Evans, for counsel throughout this project, counsel which comes from a lifelong understanding of and affection for this place.

ABOUT THE PHOTOGRAPHER

For twenty-six years, Terry Evans lived in Salina, Kansas, photographing prairie from its native state to its use, abandonment, and restoration as well as its inhabitants. Her work has been exhibited widely and is in the permanent collection of many museums, including the Art Institute of Chicago; the Museum of Modern Art; the National Museum of American Art, Smithsonian Institution; and the San Francisco Museum of Modern Art. She has received grants and fellowships, including a 1996 John Simon Guggenheim Memorial Fellowship and a Mid-America Arts Alliance/National Endowment for the Arts Fellowship. Other published collections of her work include *Prairie: Images of Ground and Sky* (University Press of Kansas, 1986) and *Disarming the Prairie* (Johns Hopkins Press, 1998).

She now lives in Chicago with her husband, Sam. They have two children, David and Corey.

ABOUT THE AUTHOR

Donald Worster is the Hall Distinguished Professor of American History at the University of Kansas. Since completing his Ph.D. at Yale in 1971, he has devoted his scholarly life to integrating ecology and the natural world into the study of history. His books include *Nature's Economy* (Cambridge University Press, 1994), *Rivers of Empire* (Pantheon, 1985), and *Dust Bowl* (Oxford University Press, 1979). He has been president of the American Society of Environmental History, a Guggenheim Fellow, and chairman of the board of directors of The Land Institute.

He and his wife, Bev, live near Lawrence, Kansas. Their children are William and Catherine.